W9-CPW-423

THIS DRAWING BOOK BELONGS TO

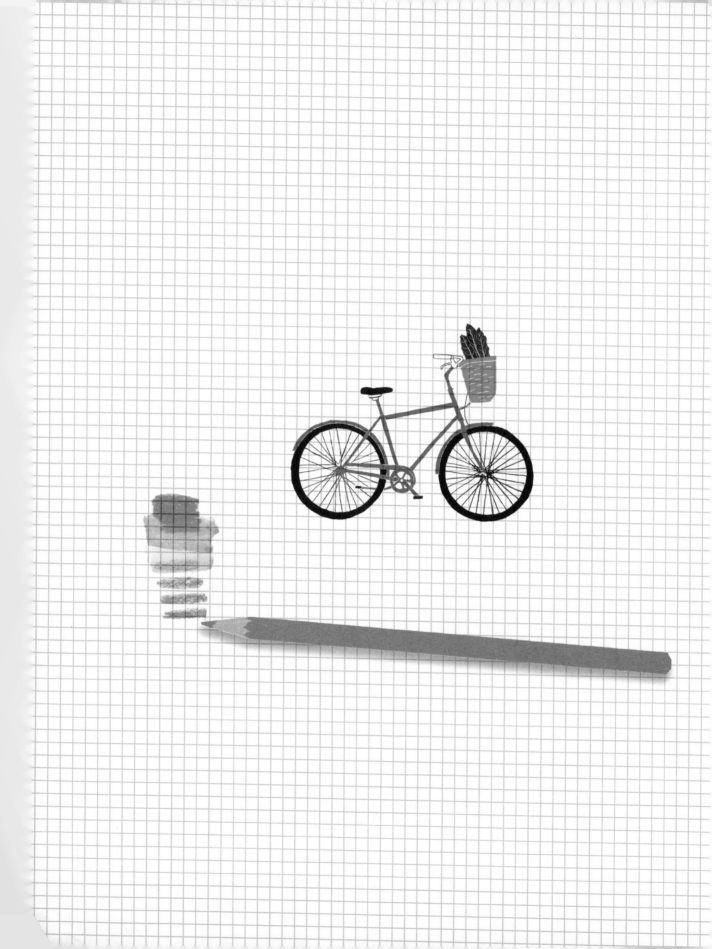

50 WAYS

TO DRAW

Your

Beautiful

ORDINARY
LIFE

PRACTICAL LESSONS IN PENCIL AND PAPER

IRENE SMIT & ASTRID VAN DER HULST & THE ILLUSTRATORS FROM *FLOW*

WORKMAN PUBLISHING • NEW YORK

Copyright © 2018 by Sanoma Media Netherlands
B.V./Flow

All artwork copyright © the individual artists

All rights reserved. No portion of this book may be
reproduced—mechanically, electronically, or
by any other means, including photocopying—
without written permission of the publisher.
Published simultaneously in Canada by
Thomas Allen & Son Limited.

Library of Congress Cataloging-in-Publication
Data is available.

ISBN: 978-1-5235-0115-1

Design by *Flow* magazine and
Lisa Hollander at Workman Publishing

Special thanks to Caroline Buijs and
Marjolijn Polman at *Flow*.

Workman books are available at special discounts
when purchased in bulk for premiums and
sales promotions as well as for fund-raising or
educational use. Special editions or book excerpts
can also be created to specification. For details,
contact the Special Sales Director at the address
below, or send an email to specialmarkets
@workman.com.

Workman Publishing Co., Inc.
225 Varick Street
New York, NY 10014-4381
workman.com

flowmagazine.com

FLOW® is a registered
trademark of Sanoma Media
Netherlands B.V.
WORKMAN is a registered
trademark of Workman Publishing Co., Inc.

Printed in China
First printing March 2018

10 9 8 7 6 5 4 3

Contents

INTRODUCTION
page 1

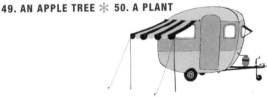

CRETACOLOR NERO soft 2 461 02 Austria

Irene *Astrid*

Life is art; art is life.

At *Flow*, we believe perfection in art is an oxymoron and that truly great artists are the people who simply *begin*—in order to see what they make along the way. And we've always encouraged our readers to take creative leaps, building their wings on the way down. Since *Flow*'s inception, we've had the unique opportunity to work with truly talented artists and illustrators and, for this book, we've asked a few of them to create lessons on drawing ordinary objects from their everyday lives and imaginations. While the subject matter may seem fairly ordinary—how to draw an apple tree, a cat, items on your desk, a swim cap—it's in the act of drawing that the beauty of the ordinary shines through.

In these mini master classes, you'll learn about methods of artistic expression—watercolor, sketching, and tracing. Whether you're looking to get your creative juices flowing, or simply for an activity to help you hit pause during a busy day, just remember: It's not about the end result—it's about your creative journey.

We hope you have fun and get inspired!

XO,
Astrid & Irene

Part 1
HOME

how to draw **A CUP & SAUCER**
by KATRIN COETZER

1. Draw two oval shapes.

2. Draw four curved lines.

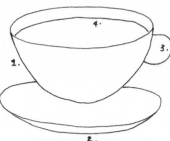

3. Add some shading.

HERE
HERE
HERE

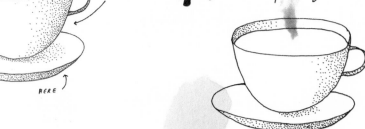

4. Don't forget a wisp of steam!

5. Now add some accessories.

PATTERN

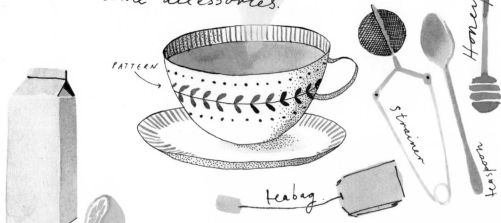

Strainer

Honey

teaspoon

teabag.

milk or lemon?

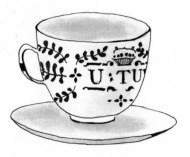

how to draw **A HOUSE**
by DEBORAH VAN DER SCHAAF

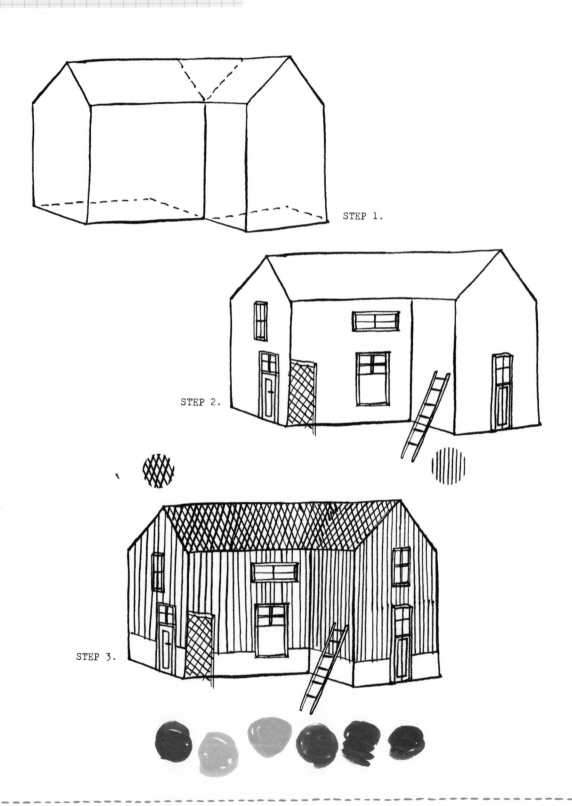

STEP 1.

STEP 2.

STEP 3.

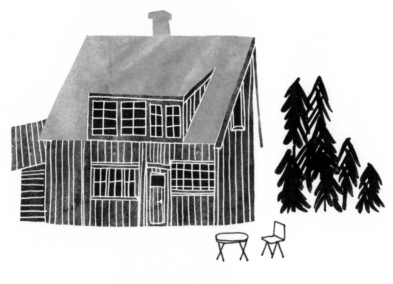

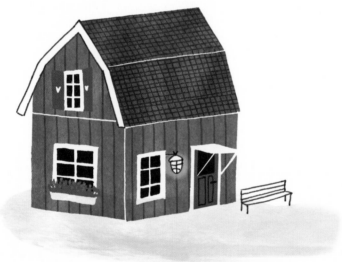

how to draw A KITCHEN CUPBOARD
by EMILY ISABELLA

Step 1.

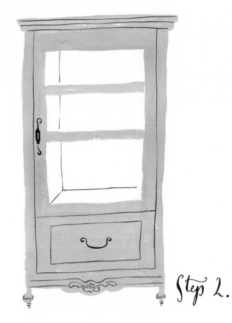

Step 2.

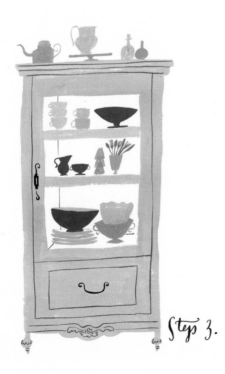

Step 3.

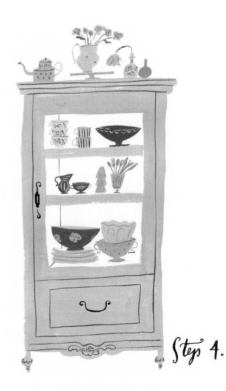

Step 4.

Draw your own kitchen cupboard, or
the one you would like to have, and
fill it with your favorite dishes.

4

how to draw **A TABLE & CHAIRS**
by YELENA BRYKSENKOVA

STEP 1.

STEP 2.

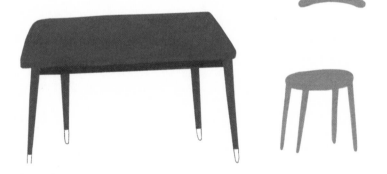

STEP 3.

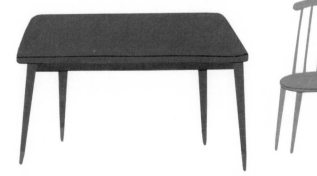

STEP 4.

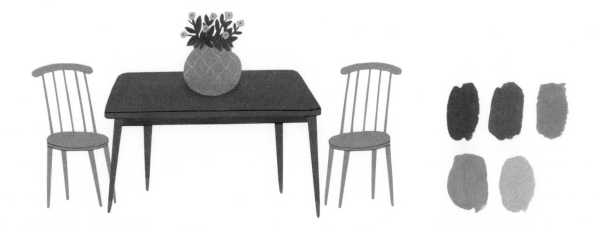

how to draw **A BLANKET & SOCKS**
by FLORA WAYCOTT

1. Draw the outline of the blanket and socks.

2. Add patterns.

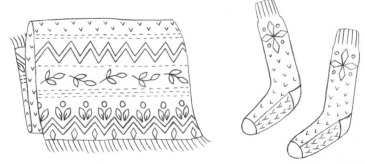

3. Color in the background and fill in the patterns.

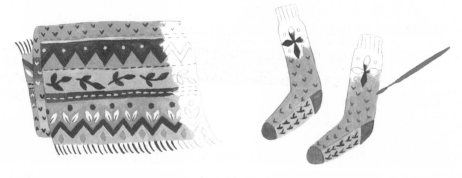

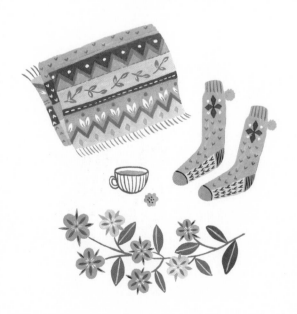

Some blanket and sock ideas

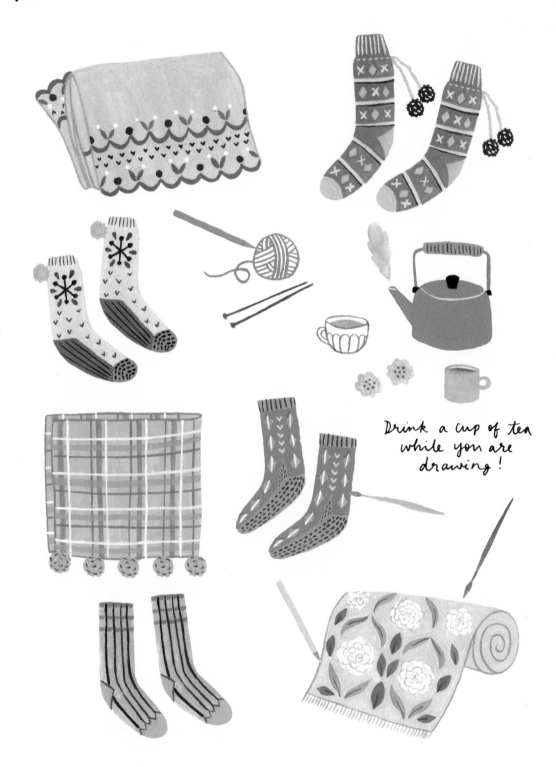

Drink a cup of tea while you are drawing!

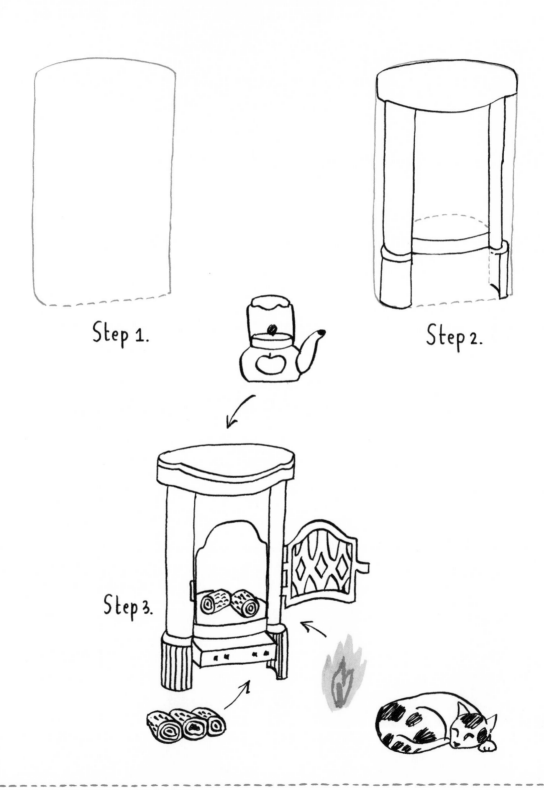

6

how to draw **A WOOD-BURNING STOVE**
by DEBORAH VAN DER SCHAAF

Step 1.

Step 2.

Step 3.

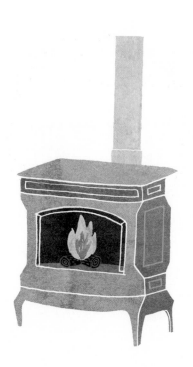

how to draw **A BOOKCASE**
by BODIL JANE

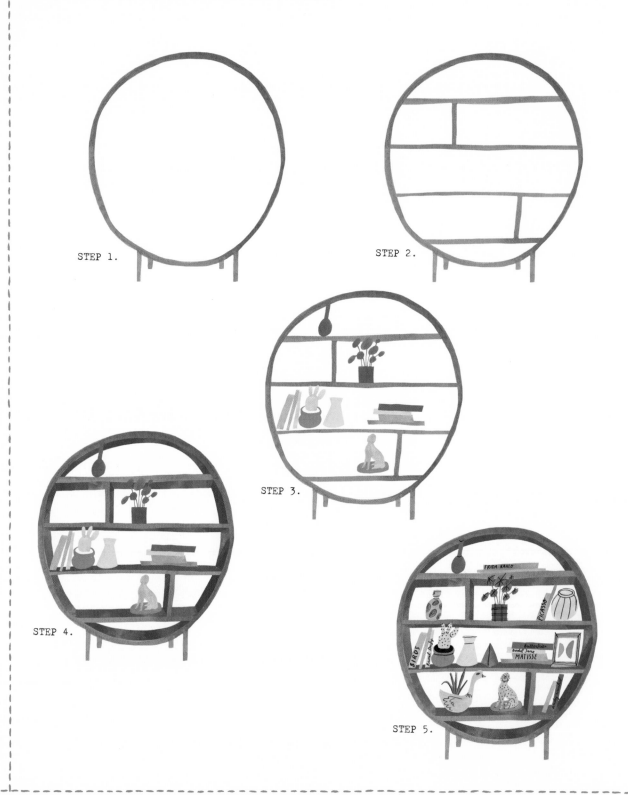

STEP 1.

STEP 2.

STEP 3.

STEP 4.

STEP 5.

Once you've drawn your bookcase,
look closer and make larger studies
of the items on the shelves.

how to draw **THINGS ON YOUR DESK**

by SANNY VAN LOON

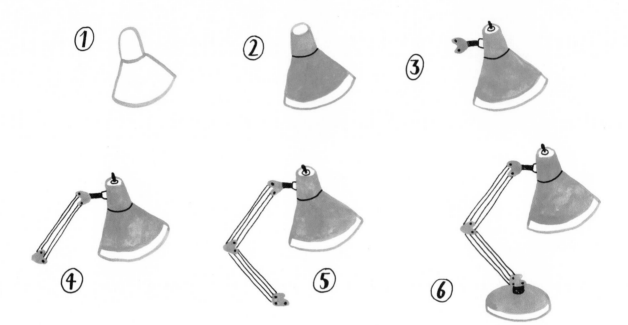

① ② ③

④ ⑤ ⑥

Look around your desk and inside
your drawers for more inspiration.

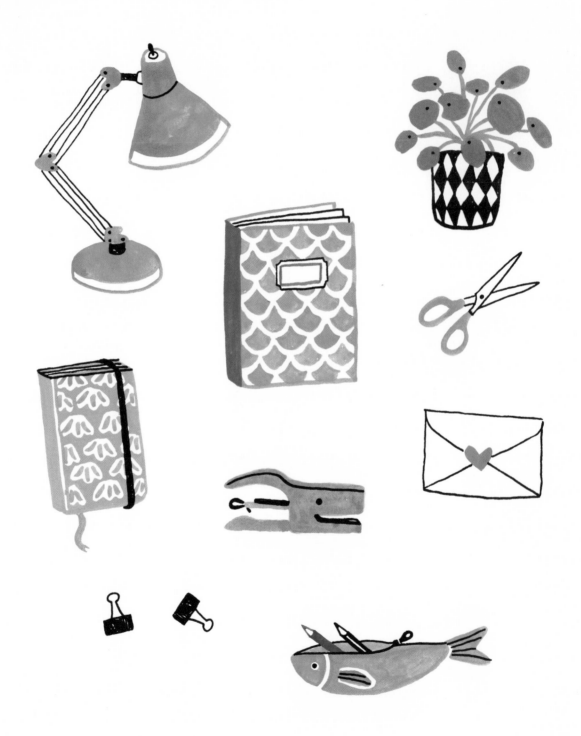

Carolyn Gavin

CAROLYN GAVIN grew up in Johannesburg, South Africa, and now spends her days working on her homey floral designs in her 116-year-old Victorian home in Toronto, Canada. Carolyn likes to use black ink as a medium for her work and is inspired by looking at the world surrounding her.

She buys her supplies from the DeSerres art store and is excited about the color combinations of hot pink and just about any other color. Becoming an illustrator satisfied her intense need to create, and has even inspired her daughter, who is her muse, to become an artist. Carolyn prefers the sound of her bulldog snoring when working on projects and practices yoga and gardening in her spare time.

LOCATION: **Toronto, Canada**

INSTAGRAM: **@carolynj**

WEBSITE: **carolyngavinshop.etsy.com**

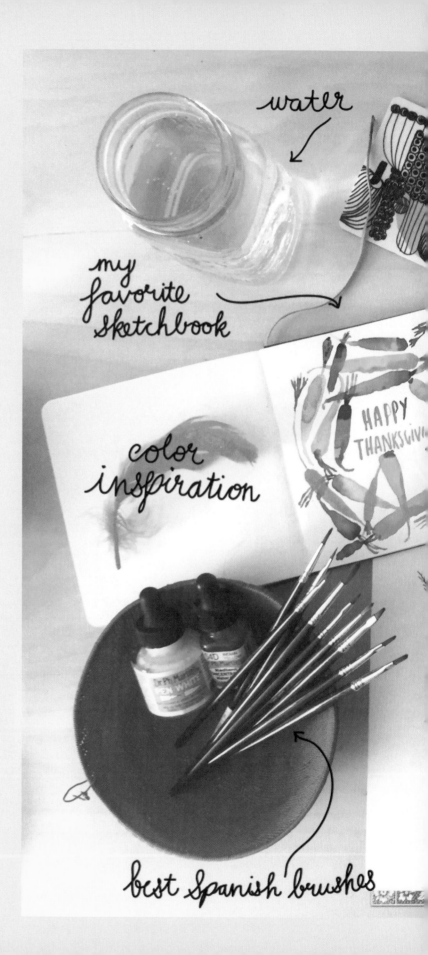

water

my favorite sketchbook

color inspiration

HAPPY THANKSGIVIN

best Spanish brushes

larimekko
coaster

bottles
of
ink

best painting
cup

African bowl

ink pen

flowers
always

heirloom
carrot
painting

how to draw A WICKER CHAIR
by BODIL JANE

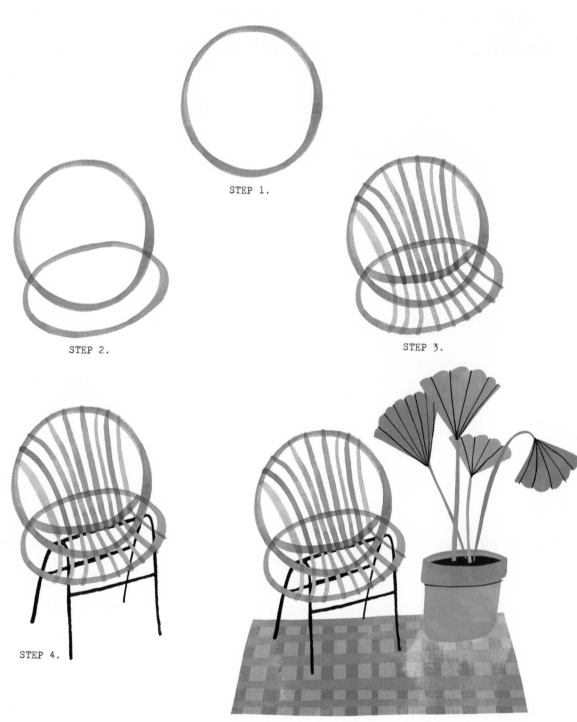

STEP 1.

STEP 2.

STEP 3.

STEP 4.

STEP 5.

how to draw JAM JARS IN A PANTRY
by KATRIN COETZER

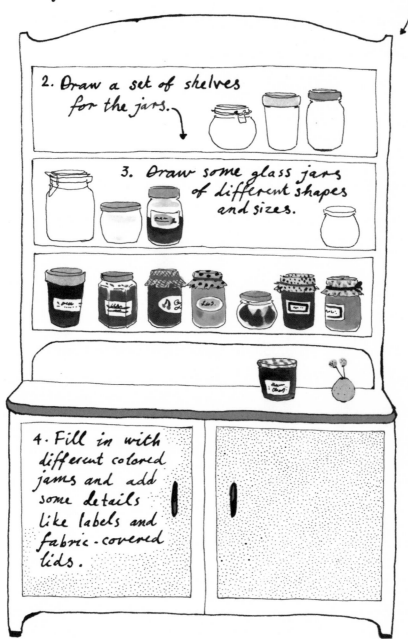

1. Begin by outlining the shape of the pantry.

2. Draw a set of shelves for the jars.

3. Draw some glass jars of different shapes and sizes.

4. Fill in with different colored jams and add some details like labels and fabric-covered lids.

Do you have a favorite jam recipe?
Try illustrating it on a recipe card
(see page 110 for tips).

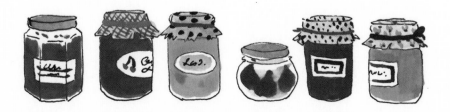

how to draw **A SEWING BOX**
by ANNEMOON VAN STEEN

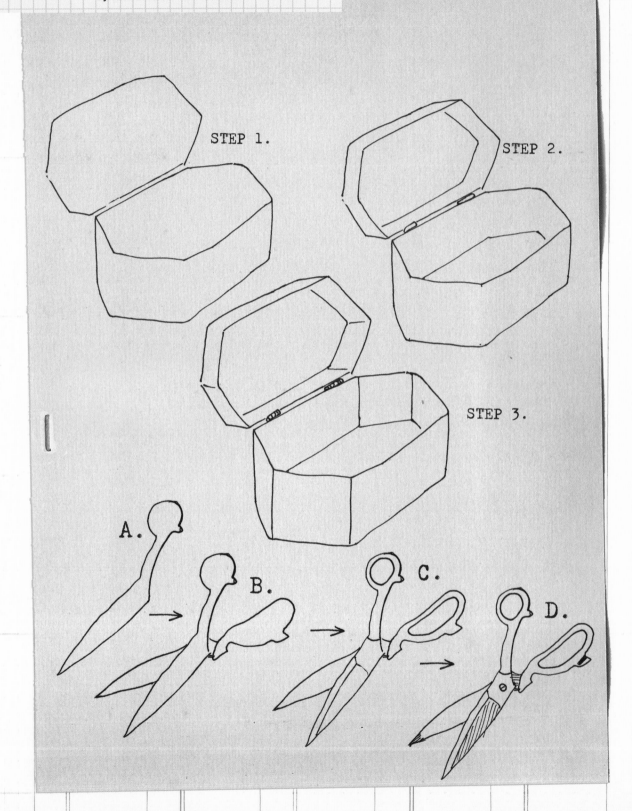

STEP 1.

STEP 2.

STEP 3.

A.

B.

C.

D.

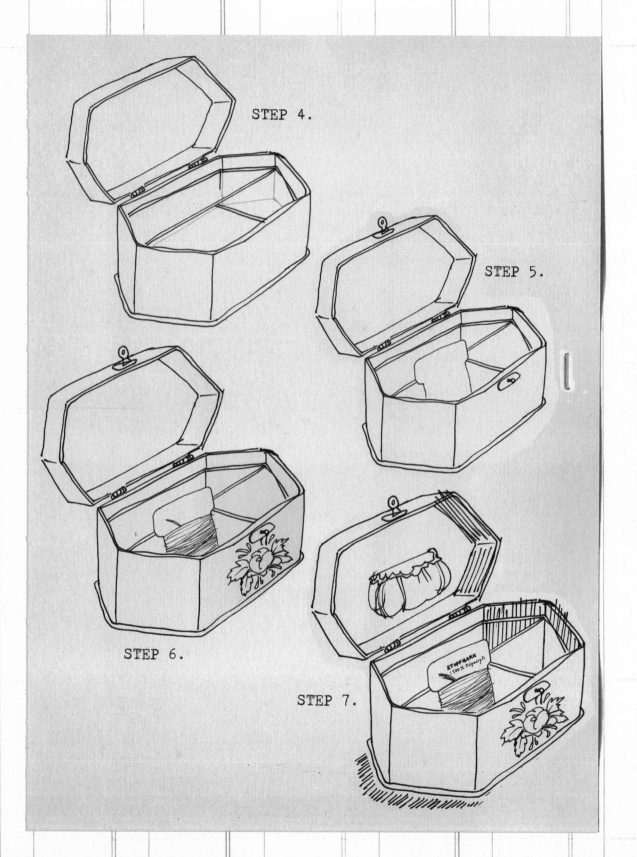

STEP 4.

STEP 5.

STEP 6.

STEP 7.

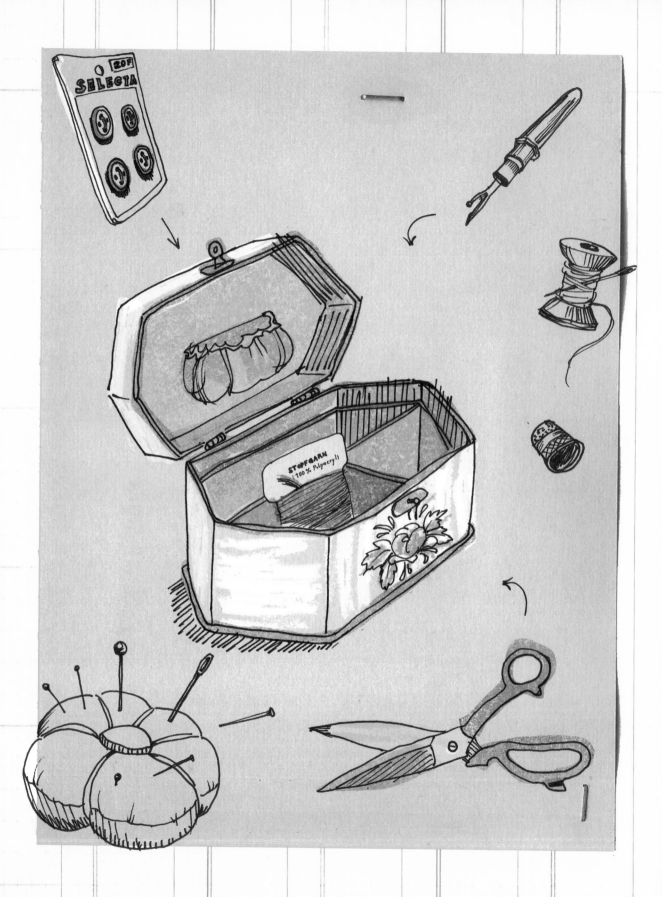

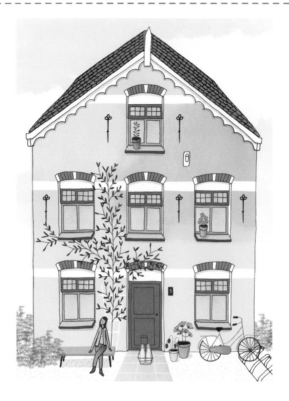

A House to Draw In

by Karen Weening

BRUSH UP ON THE BASICS OF PERSPECTIVE DRAWING

WITH THE STEPS ON THE OPPOSITE PAGE AND PRACTICE DRAWING

YOUR BATH, BED, OR CHAIRS JUST SO. THEN TURN THE PAGE

TO THE ILLUSTRATED HOUSE FOLDOUT AND FILL IN THE FURNITURE:

DRAW IT WHEREVER YOU WANT, AND AS CROOKED AS YOU LIKE.

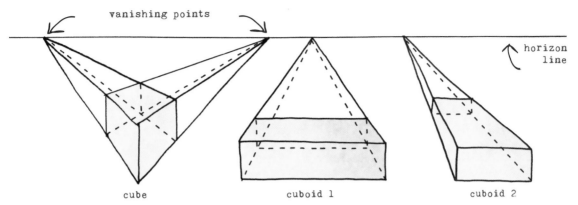

vanishing points

horizon line

cube

cuboid 1

cuboid 2

1 Try this: Draw your piece of furniture based on an easily drawn shape. A cube represents a square chair, a cuboid represents a bathtub, bed, or couch, and a cylinder (not pictured) can represent a vase. The lines of your 3-D forms converge into one point (see cuboids above), or into two points (see cube above). These disappearing points are all on the horizon line, of which there is only one. Note: It's possible that the horizon line may not be visible on your page. In that case, just draw the lines toward the point beyond your paper.

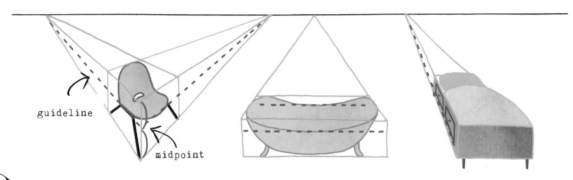

guideline

midpoint

2 Now draw the furniture within your shapes, sketching in guidelines to help you. For example, the legs of the chair come halfway up the full chair (giving way to the seat), so draw a guideline halfway up the square that is representing your chair. This guideline should converge with the other lines at the vanishing point. Apply the same concept to the other pieces of furniture, dividing the shape in halves, thirds, or quarters and adding guidelines as needed.

3 Use shading and details to make your furniture appear even more three-dimensional. Adding shadows indicates a light source in a room. Other details lend a sense of specificity—draw some water for a bath in the bathtub, add a pattern to the bedsheets, perhaps a cat curled up at the foot of the bed! Even if the perspective isn't spot on, the added depth will make it look more realistic. You can use your own home as inspiration, look online for beautiful home tours, or let your imagination run wild.

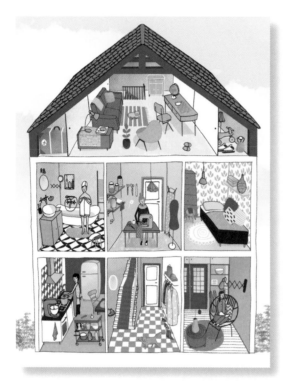

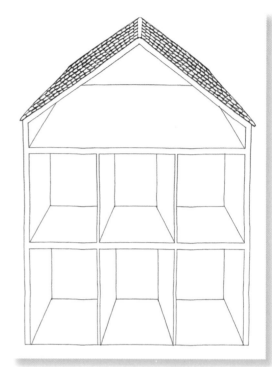

Your Turn

HERE YOU HAVE TWO HOUSES: ONE ILLUSTRATED

BY KAREN WEENING TO INSPIRE YOU

AND ONE THAT YOU CAN DECORATE WITH FURNITURE

AND WALLPAPER DRAWN BY YOU.

how to draw A SIDEBOARD

by ANNEMOON VAN STEEN

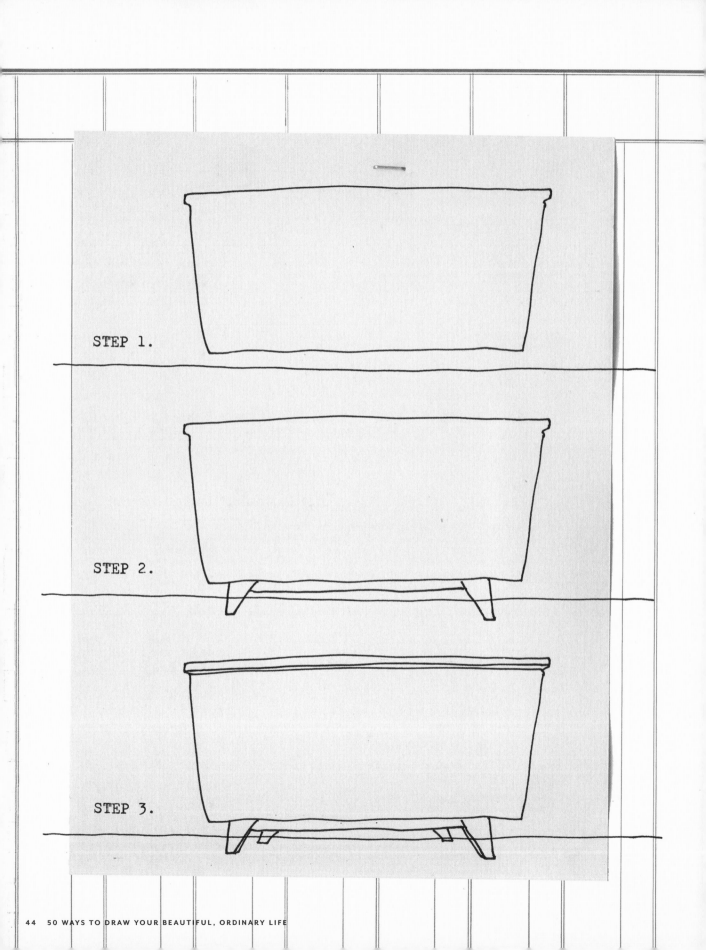

STEP 1.

STEP 2.

STEP 3.

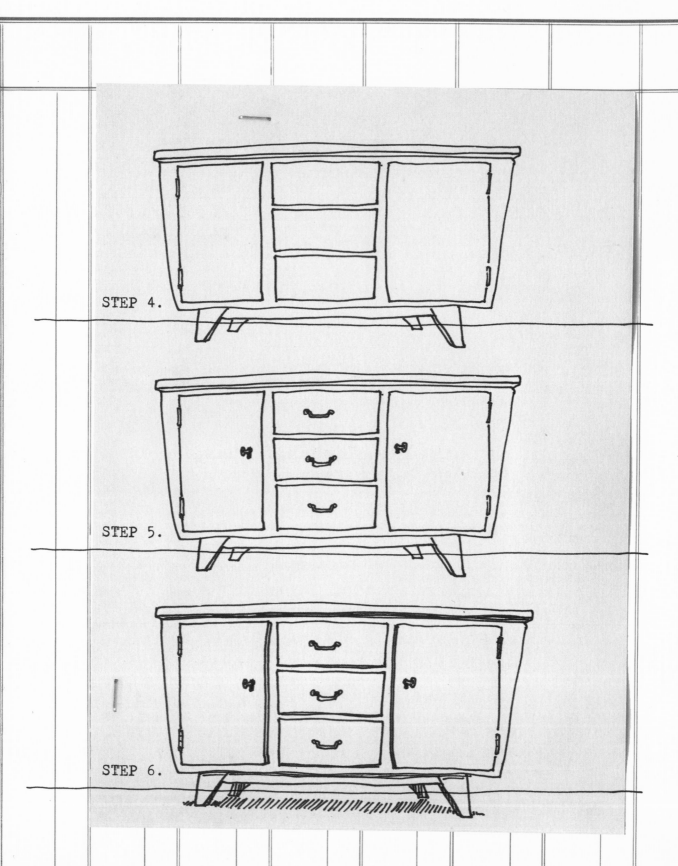

STEP 4.

STEP 5.

STEP 6.

how to draw **A DESK**
by **KATRIN COETZER**

STEP 1.

STEP 2.

STEP 3.

STEP 4.

STEP 5.

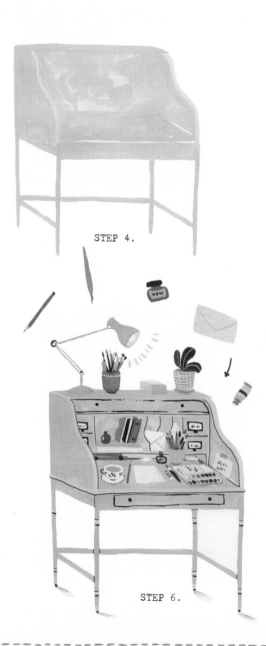

STEP 6.

Every desk looks different—draw the
main shape, then add details to create
your own unique work space.

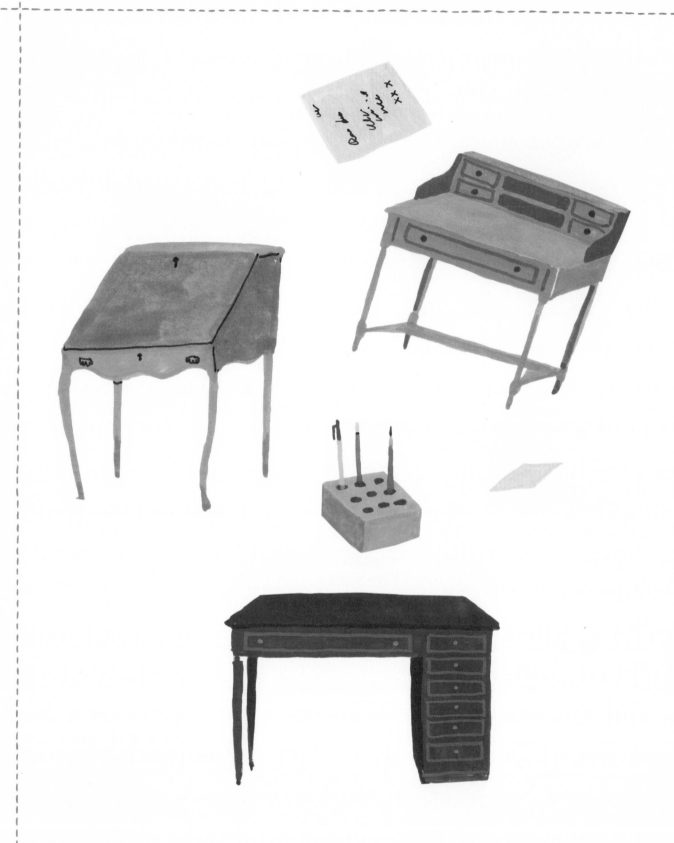

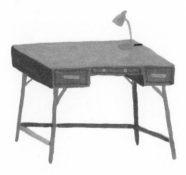

how to draw A FILTER COFFEEPOT
by AMY VAN LUIJK

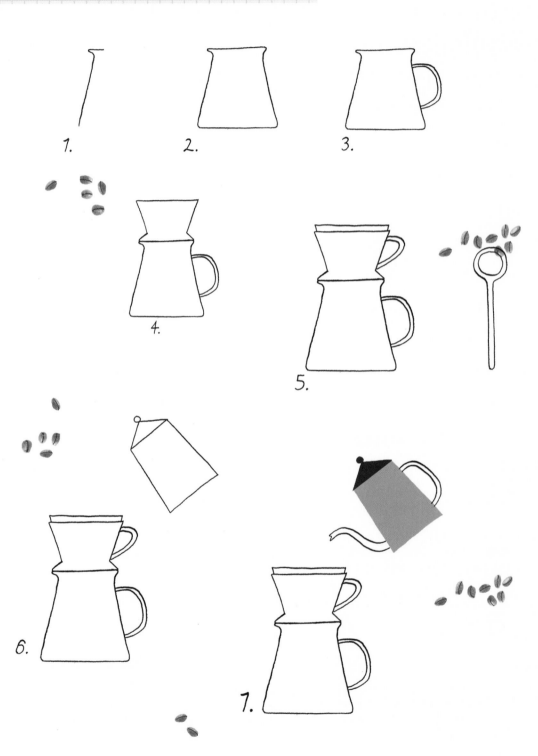

1.

2.

3.

4.

5.

6.

7.

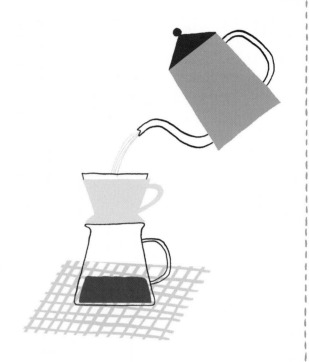

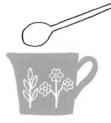

how to draw **A FRUIT WRAPPER**
by KATRIN COETZER

1. Draw a basic outline.

2. Draw a central pattern.

3. Choose an emblem (e.g., rooster, elephant, peacock, saint, etc.).

4. Add some fruit, rays of sunlight, and the place of origin.

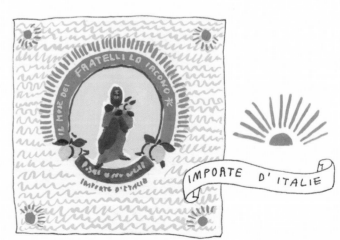

IMPORTE D'ITALIE

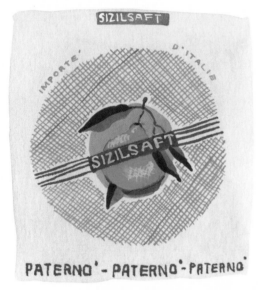

Green Light for Tracing

TRACING IS PERFECT FOR DAYS WHEN YOU'RE NOT

INSPIRED, OR JUST WANT TO COMPLETE A SIMPLE EXERCISE.

AND USING TRACING PAPER ISN'T THE ONLY WAY TO DO IT.

Illustrator Juliette Berkhout: "Tracing can be a great way to create any image you want, and a light box, a light source that illuminates the paper from below, is a perfect aid. You can trace over pictures as much as you want, figuring things out: how someone sits at their desk, how they bend down to pick something up, what a bike looks like exactly. Tracing can be an exercise, a study of something, that leads to you creating your own work."

Illustrator Monique Wijbrands: "If it's not dark outside, you can use your window as a light box. Tape a picture, preferably printed on thin paper with strong contrasts, onto your windowpane. You might want to increase the contrast in the picture before you print it. Tape a second sheet of paper over the first one and start tracing."

how to draw **A LAMP**
by **KATRIN COETZER**

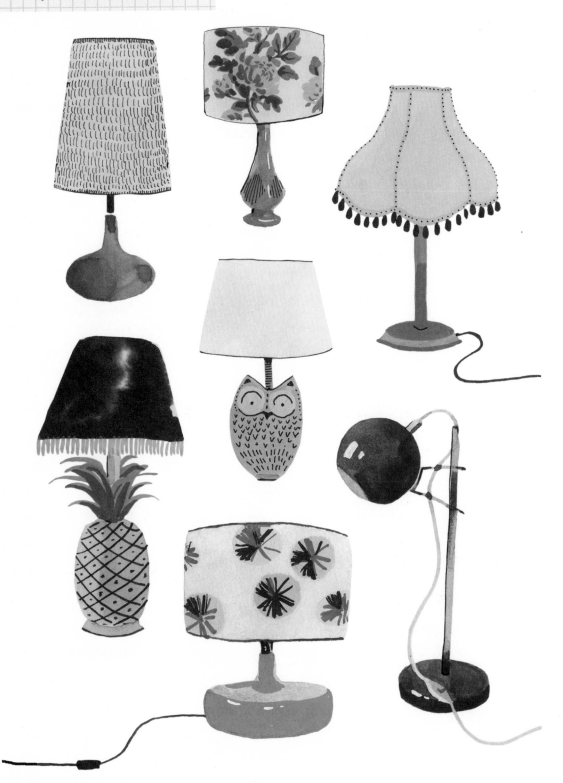

1. Draw the base.

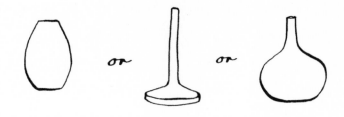

or or

2. Draw the shade.

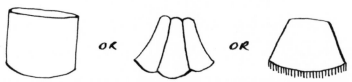

OR OR

3. Decorate with a retro fabric print and a ceramic glaze.

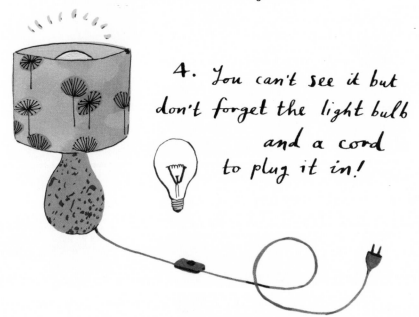

4. You can't see it but don't forget the light bulb and a cord to plug it in!

how to draw **AN OLD MATCHBOX**
by ANNEMOON VAN STEEN

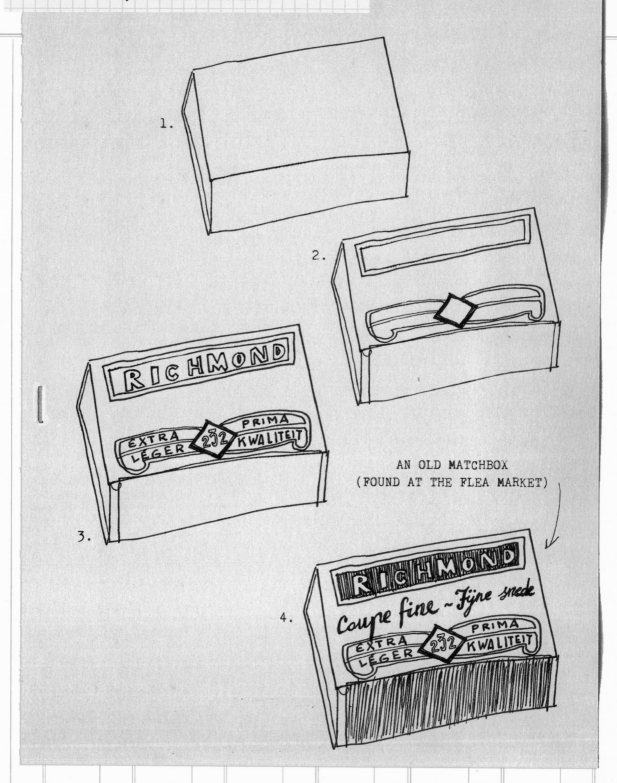

1.

2.

3. RICHMOND
EXTRA LÉGER 232 PRIMA KWALITEIT

AN OLD MATCHBOX
(FOUND AT THE FLEA MARKET)

4. RICHMOND
Coupe fine ~ Fijne snede
EXTRA LÉGER 232 PRIMA KWALITEIT

how to draw **A TEAPOT**
by KATRIN COETZER

1. Start by drawing a generous circle.

2. Draw a base, a spout, and a lid.

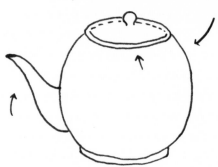

3. Choose to add a handle on the side or on top.

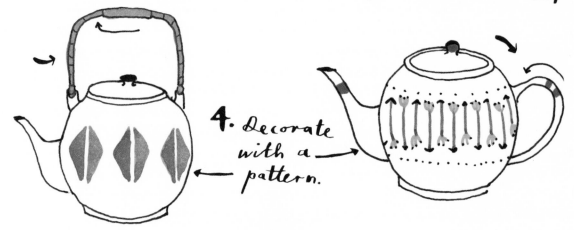

4. Decorate with a pattern.

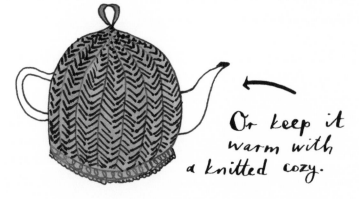

Or keep it warm with a knitted cozy.

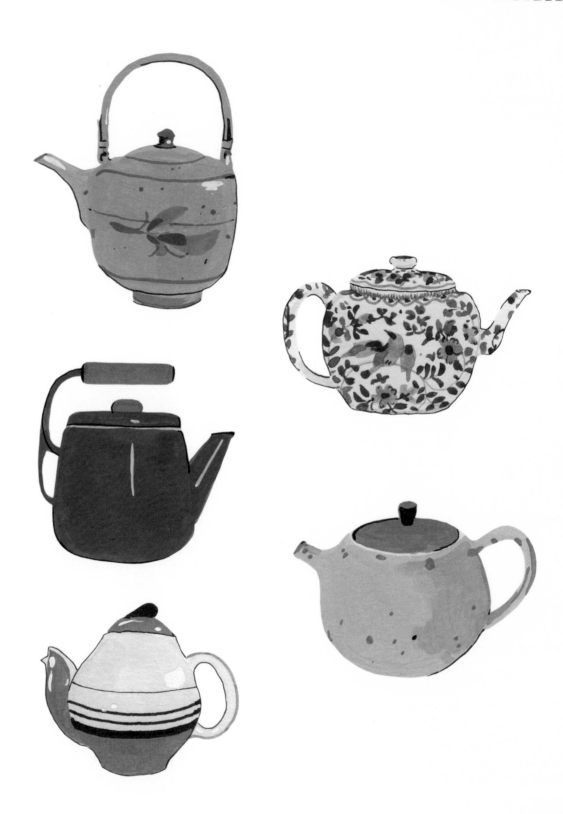

Just Start

by Caroline Buijs

YOU MAY HAVE BEEN TAUGHT THAT, WHEN DRAWING, YOU HAVE
TO DRAW YOUR SUBJECT AS TRUE TO LIFE AS POSSIBLE.
BUT WHY, EXACTLY? THE NEW RULE WE'VE LEARNED—
AND THE BEST ONE SO FAR—IS THAT THERE ARE NO RULES.
HERE ARE A FEW INSIGHTS AND IDEAS TO GET YOU STARTED.

1 Do you spend a lot of your time hunched over your paper, forgetting to look properly at what you're drawing? Try to keep your eyes on what you're drawing 80 percent of the time, and on the paper 20 percent.

2 Now draw what you are actually seeing, not what you think you are seeing. You might think a plate is a circle, but from where you're sitting, the shape is probably an oval. Believe what your eyes are showing you, not what your mind is telling you.

3 Don't worry about perspective. There are a lot of rules for drawing perspective correctly, but you only need to remember a few: Things that are farther away look smaller. The building in front of you has straight lines on the front, but the sides run away in a kind of triangle-y shape. You don't need a calculator or rules to be able to see this. Look carefully and draw what you see. And most of all, don't forget: You are not an architect. It doesn't have to be perfect.

4 Yes, tracing is allowed (see page 58), particularly when you are just beginning. It will give more substance to the lines as you draw. While you are tracing, you can try out all kinds of different materials, too. This will build your self-confidence for when you want to start drawing without tracing.

5 The use of light and shade is easy to forget when you are drawing. Hatching, a technique that uses small overlapping marks to give the effect of shading, is a great and rather simple way to add a variety of tone to your work.

6 Who says the sky always has to be blue? Or the grass green? Dare to use a different color—you'll be amazed at the results.

7 Find a drawing you made a few weeks ago and that still needs work. Add some watercolors, or color in parts of the drawing with colored pencils. You can also add a new bit to the drawing. This way, you keep your drawing alive.

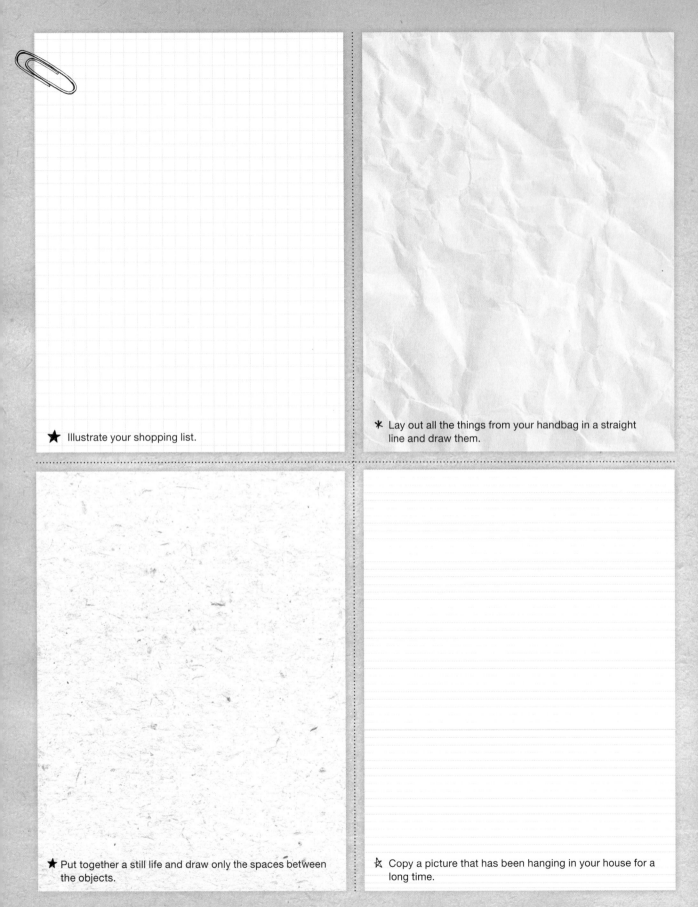

★ Illustrate your shopping list.

✳ Lay out all the things from your handbag in a straight line and draw them.

★ Put together a still life and draw only the spaces between the objects.

✰ Copy a picture that has been hanging in your house for a long time.

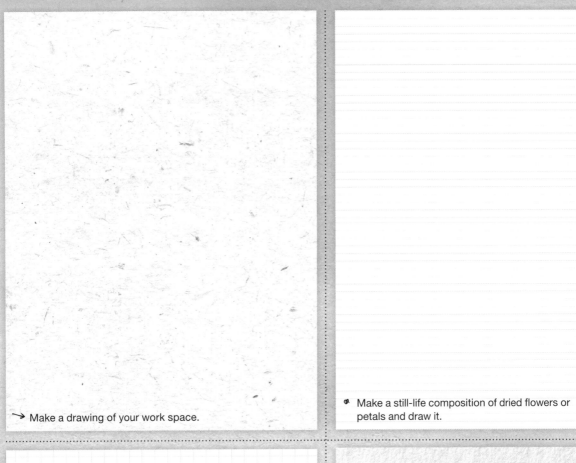

→ Make a drawing of your work space.

✿ Make a still-life composition of dried flowers or petals and draw it.

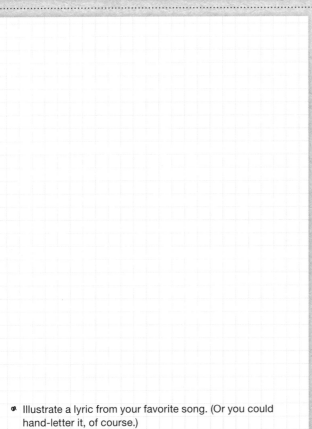

✿ Illustrate a lyric from your favorite song. (Or you could hand-letter it, of course.)

✳ Glue half of a picture on your paper and draw in the other half by hand.

✯ Pick one subject and draw various things that are all related to it on this page. Your cat in six different poses, for example. All of the spoons from your kitchen, from teaspoon to gravy dipper. Receipts from your purse, and so on.

Cut a lemon or orange in half and draw it.
Paint it with watercolors.

Collect the seed husks of different flowers and draw them.

For a month, draw the view from your window every day.
Start here.

Make a drawing with your eyes closed.

★ Freeze-frame your favorite video clip at the one-minute mark and draw the frozen image.

→ Illustrate your day in a mini cartoon.

* Cut out shapes from beautiful paper, then glue them on your paper and draw around them. For example, a half-circle can become the skirt of a little doll.

✫ Glue a picture of yourself on your paper. Draw things that make you happy around it.

Part 2

GARDEN

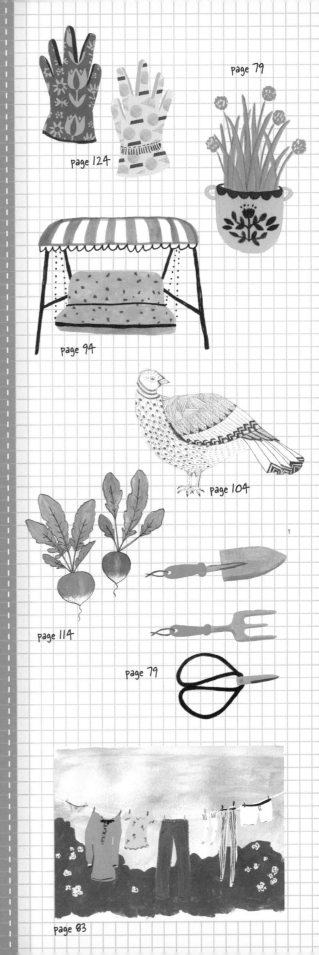

page 79

page 124

page 94

page 104

page 114

page 79

page 83

*

Garden-related
drawing lessons

*

Mini sketchbook for
your drawings

*

Inspiration from
space limitations

*

Colored paper

*

Nine ways to draw
a plant

*

how to draw AN HERB GARDEN
by FLORA WAYCOTT

1. Draw different styles of pots.

2. Draw some herb varieties.

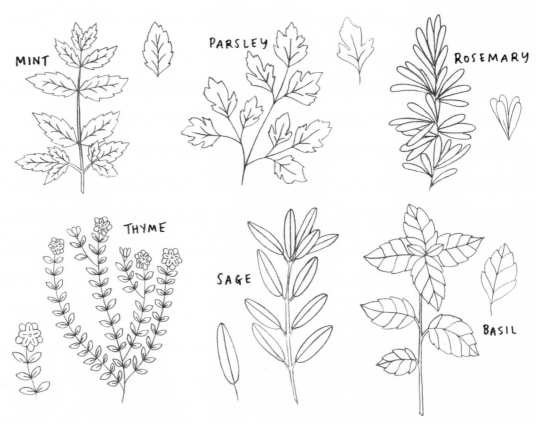

MINT

PARSLEY

ROSEMARY

THYME

SAGE

BASIL

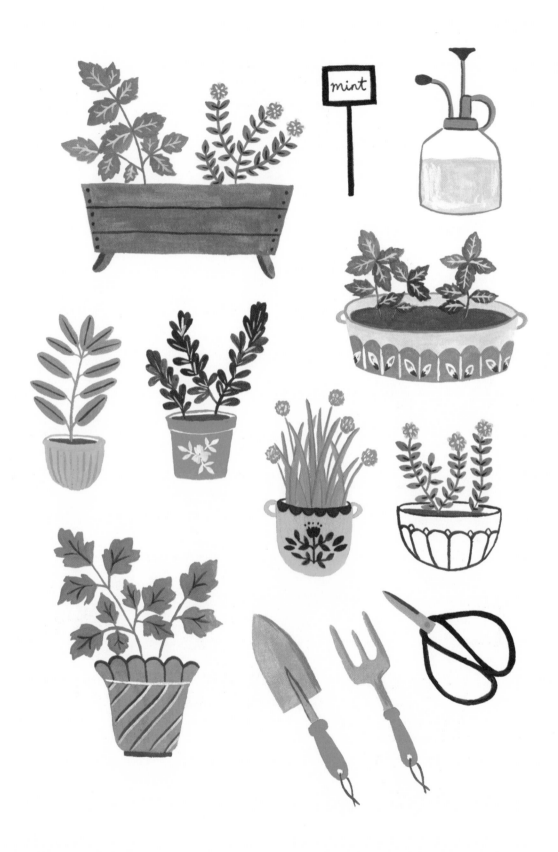

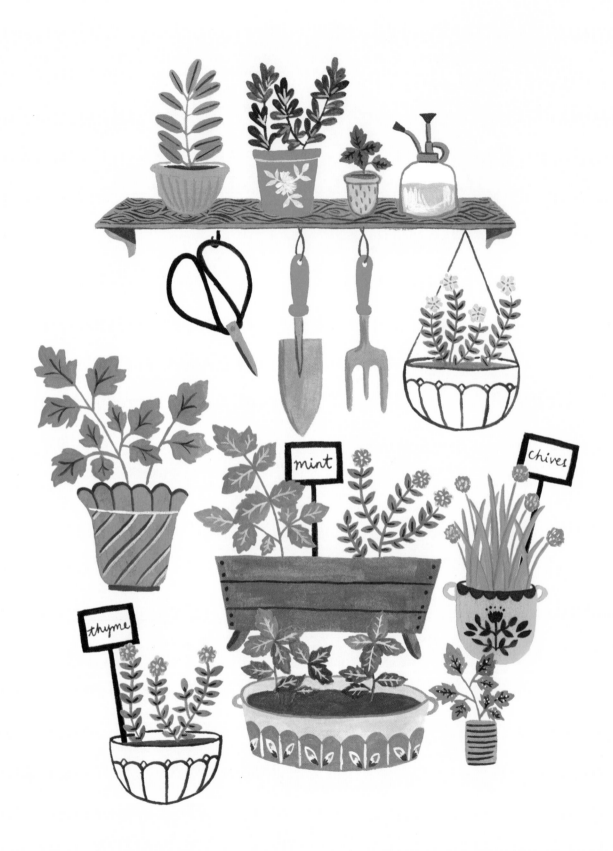

how to draw A CLOTHESLINE
by EMILY ISABELLA

Step 1.

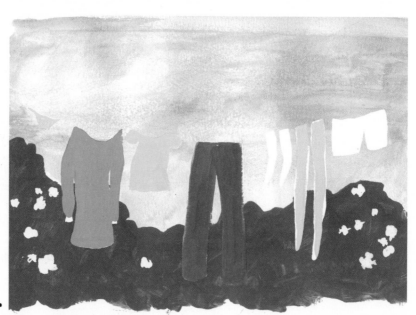

Step 2.

This is a good exercise in drawing
environments—focus on the negative space
and background first.

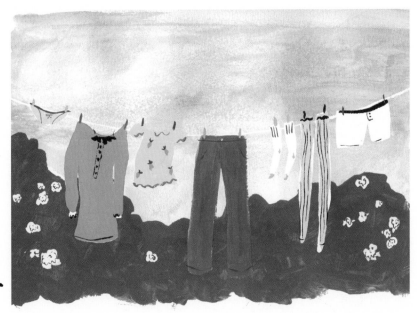

Step 3.

21

how to draw **A FLOWERPOT**
by ANNEMOON VAN STEEN

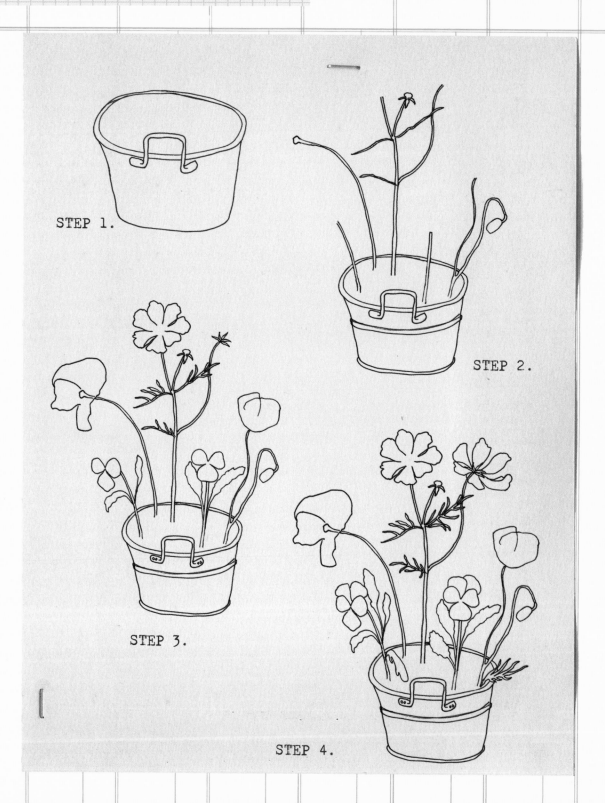

STEP 1.

STEP 2.

STEP 3.

STEP 4.

Practice Steps 1–4 here,
then turn the page to complete
Steps 5–7.

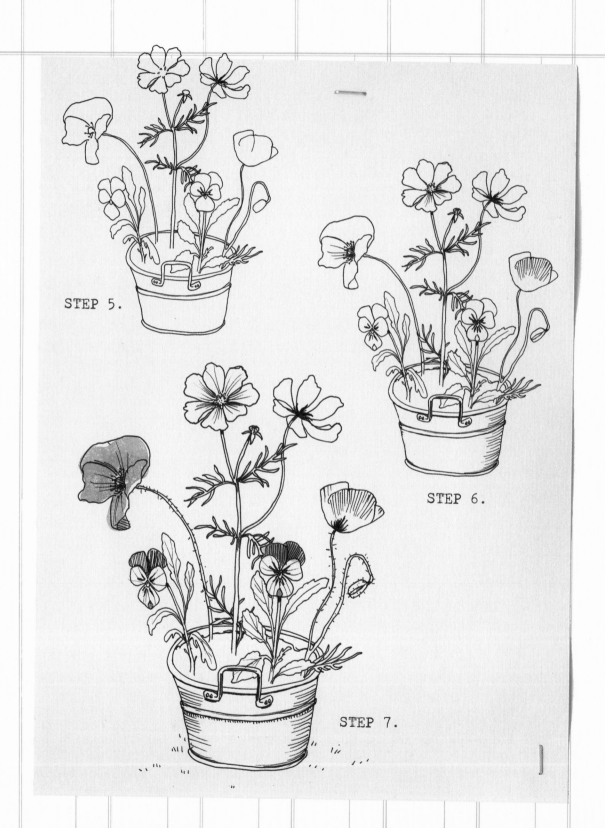

STEP 5.

STEP 6.

STEP 7.

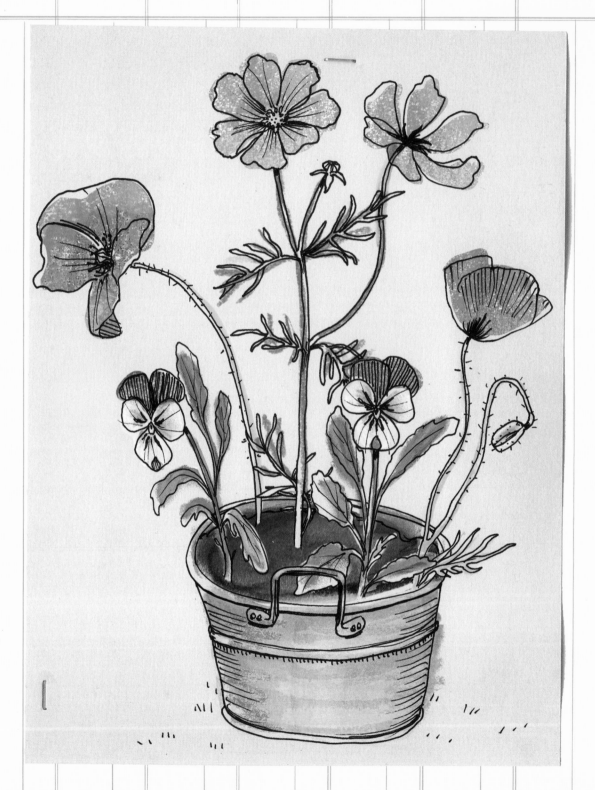

Draw Inside the Box

illustrated by Sayaka Sugiura

USE THE LIMITATIONS OF SPACE TO AID YOUR DRAWING.

A SMALL SPACE SIMPLY DOESN'T ALLOW FOR ANYTHING COMPLICATED.

RECORD A FEW THINGS THAT HAPPENED IN YOUR DAY: THE STEPS TAKEN WHEN

PREPARING YOUR MEAL, A VISIT TO A MUSEUM, OR ANYTHING YOU LIKE.

YOU CAN ALSO DRAW THE STORY OF YOUR VACATION, AS JAPANESE

ILLUSTRATOR SAYAKA SUGIURA DID (SEE OPPOSITE PAGE). YOU CAN

DECIDE WHERE TO ADD ANY TEXT—IF ANY—IN OR NEXT TO THE LINES.

Dear Mr. & Mrs. Harris,

Hi!
I'm Sayaka.
I stayed at your B&B in June.
Thank you so much!
We really enjoyed our trip.

Your B&B's room was the most comfortable on the trip. All the furnishings were lovely!

I was very pleased with "English breakfast."
I tried to cook it in Tokyo.

I love thrift shops!

We could support a charity and buy very cheaply... It's a nice idea!

After that, we visited some little villages in the Cotswolds by car.

Many houses had a lot of roses.

And there were a lot of sheep on the hill!

And we stayed in London 3 days.

"Kew Gardens" was splendid!

Thank you very much for grand memories!
Lots of love.
Sayaka

how to draw A WATERING CAN
by FLORA WAYCOTT

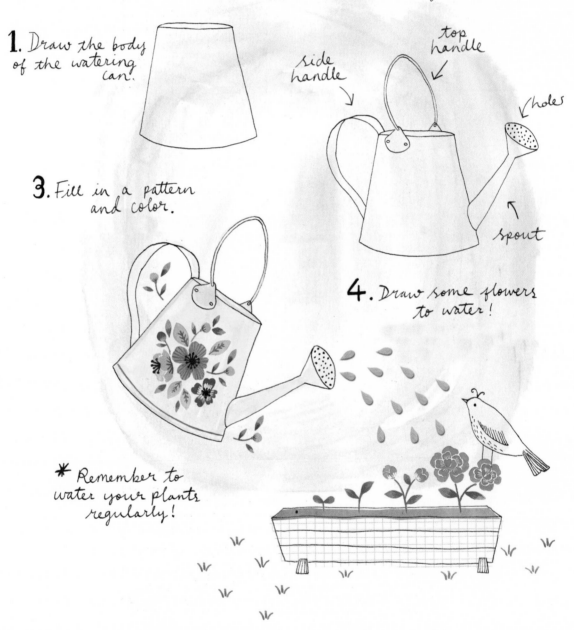

1. Draw the body of the watering can.

2. Add other elements to the body.

side handle

top handle

holes

spout

3. Fill in a pattern and color.

4. Draw some flowers to water!

✳ Remember to water your plants regularly!

how to draw **A PORCH SWING**
by SANNY VAN LOON

①

②

③

④

⑤

⑥

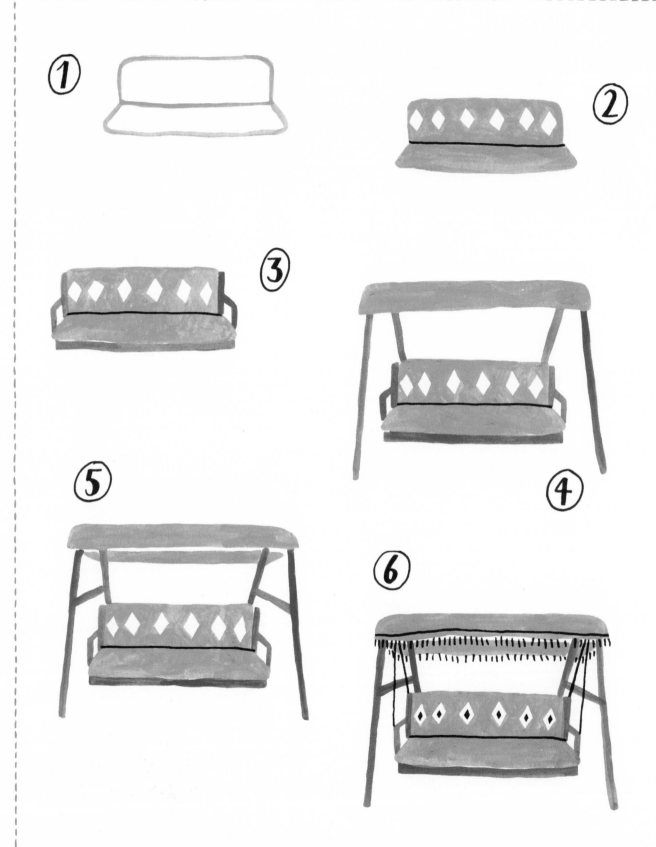

Once you've gotten the hang of
drawing the porch swing, try
adding atmospheric details like
potted plants or a side table.

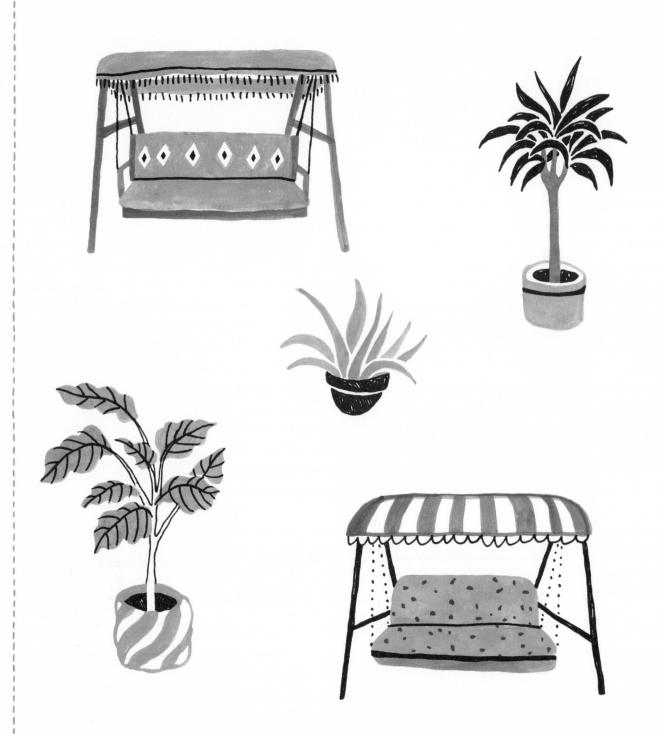

Amy Blackwell

AMY BLACKWELL resides in the Midlands, England, where she pursues her passions as a painter, printmaker, knitter, cat whisperer, writer, and reader. Inspired by the weird and wonderful, Amy enjoys exploring themes of the natural world, history, fashion, and folklore in her portraits and designs. She's a big fan of mixing bright, bold, and contemporary patterns with more traditional examples of portraiture, and believes the more clashing colors and shapes, the better. Amy also runs a small artist collective called Audrey & Illya with fellow artists and friends Leanne Narewski and Sarah Ormanroyd. The three exhibit their work collectively, plan events, and maintain an online shop, which is full of beautiful handmade gifts, housewares, and original artwork.

LOCATION: **Nottingham, England**

INSTAGRAM: **@amyjpeg**

WEBSITE: **amyblackwell.co.uk**

how to draw **A BIRD**
by **LILA RUBY KING**

1. BEAKS

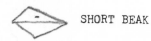
SHORT BEAK

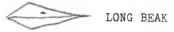
LONG BEAK

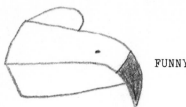
FUNNY BEAK

2. WINGS

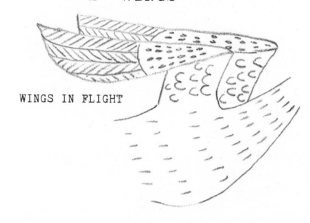

WINGS IN FLIGHT

WINGS AT REST

3. FEET

WATER FEET

GRIPPING FEET

4. TAILS

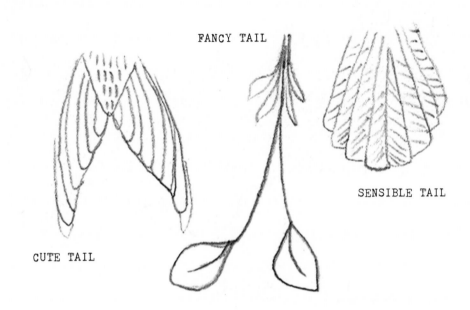

FANCY TAIL

CUTE TAIL

SENSIBLE TAIL

5. PATTERNS

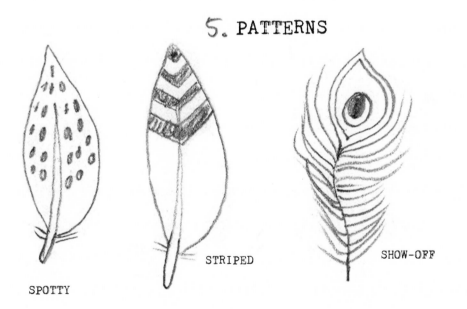

SPOTTY

STRIPED

SHOW-OFF

Put Steps 1–5 together, then fill in
the outlines with pretty patterns.

Drawing on Colored Paper

by Jennifer Orkin Lewis

FUNNY HOW WHITE PAPER IS SOMETIMES HARDER TO START DRAWING ON THAN COLORED PAPER. WHITE PAPER SEEMS SO PRISTINE, MAKING THAT FIRST MARK FEEL LIKE MORE OF A COMMITMENT. DRAWING ON COLOR CAN BE LESS INTIMIDATING, AND OFFERS A DIFFERENT PERSPECTIVE ON SHADING, HIGHLIGHTS, AND NEGATIVE SPACE.

MATERIALS

• BLACK PEN

• BLACK and WHITE PENCIL

STEP-BY-STEP

1. PENCIL MARKS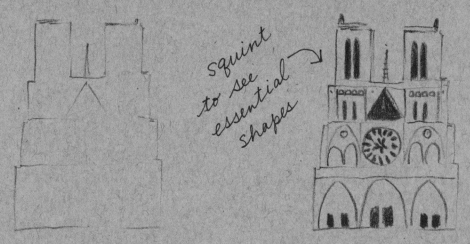

2. SKETCH A SIMPLE OUTLINE OF THE GENERAL SHAPE.

squint to see essential shapes

3. FIND THE MOST SIGNIFICANT DETAILS TO DRAW.

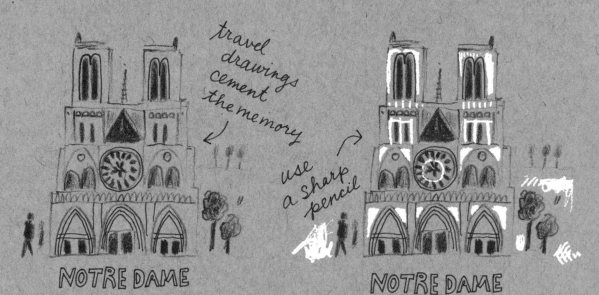

travel drawings cement the memory

use a sharp pencil

NOTRE DAME

NOTRE DAME

4. YOU CAN ADD LETTERING TO REMEMBER WHERE YOU WERE.

5. ADD SOME WHITE PENCIL DETAIL FOR POP.

how to draw **A FRUIT BOWL**
by **FLORA WAYCOTT**

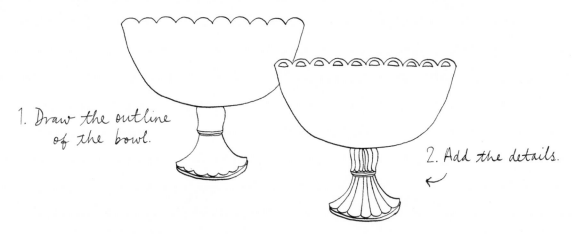

1. Draw the outline of the bowl.

2. Add the details.

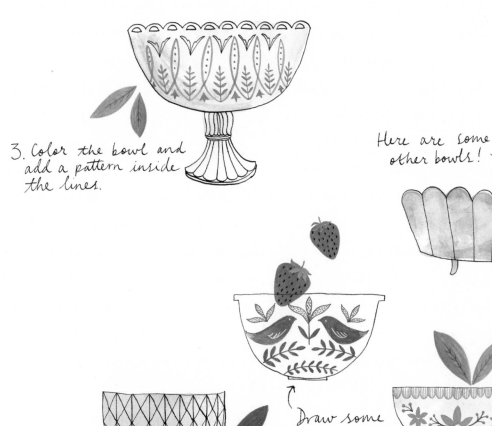

3. Color the bowl and add a pattern inside the lines.

Here are some other bowls!

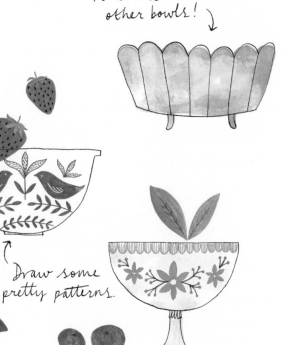

Draw some pretty patterns.

Once your bowl is complete, fill it
with your favorite fruits.

Making a Keepsake Recipe

by Deborah van der Schaaf

WHETHER YOU REGULARLY TURN TO A BELOVED, SAUCE-SPLATTERED
COOKBOOK OR A BOOKMARKED COOKING SITE BEFORE MEALTIME,
ILLUSTRATING YOUR FAVORITE RECIPE IS A BEAUTIFUL WAY TO COMMIT
IT TO MEMORY WHEN IT'S ALREADY COMMITTED TO YOUR PALATE.
FOLLOW THESE STEPS TO CREATE YOUR OWN—AND IF
YOU REALLY LIKE THE RESULT, FRAME IT!

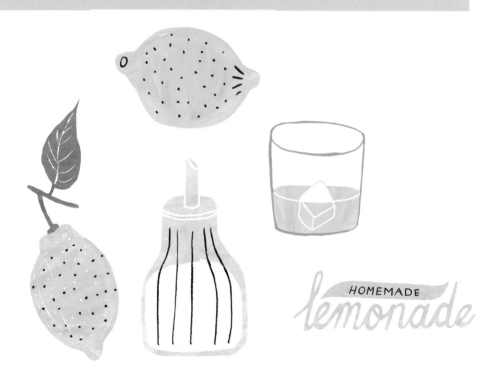

HOMEMADE lemonade

1 **Get inspired.** If you don't already have a recipe in mind to illustrate, the first step is finding inspiration. Turn to your favorite books and sites, but for other sources of inspiration, visit your local grocery store produce aisles or farmers' market—or even your own kitchen cabinet or spice drawer. What would be fun to draw? Study colors, textures, and consistency of the items.

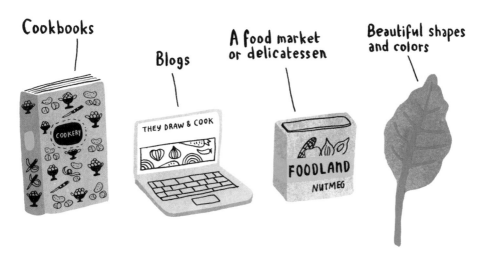

Cookbooks

Blogs

A food market or delicatessen

Beautiful shapes and colors

2 **Pick a recipe and make an outline.** Select the recipe you'd like to illustrate and start by sketching out the format—a recipe with particularly vibrant ingredients is ideal for a layout in which *all* the ingredients are illustrated.

Does the recipe have an endearing name? Try hand-lettering it. What's the star ingredient? Try repeating it visually to make a pattern or border.

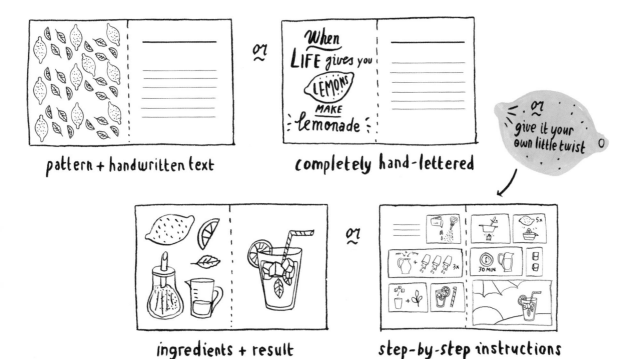

pattern + handwritten text

completely hand-lettered

ingredients + result

step-by-step instructions

3

Start drawing. Put pencil to paper to start drawing the ingredients and/or steps of the recipe. Choose the images you like best, and move them to final, adding color and arranging them on the page.

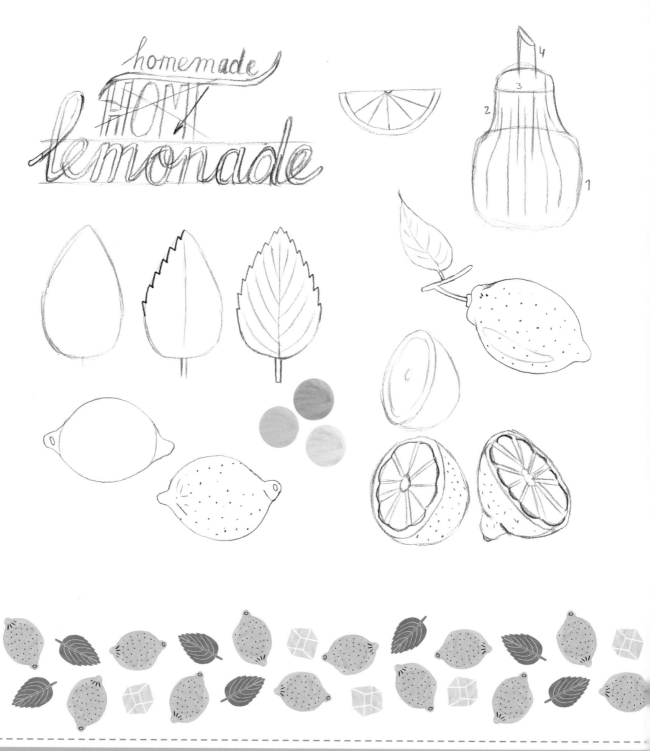

how to draw **A RADISH**
by FLORA WAYCOTT

1. Draw the outline of the body of the radish.

2. Draw the leaver.

veins →

small at the bottom →

big at the top

dots

3. Add color to finish.

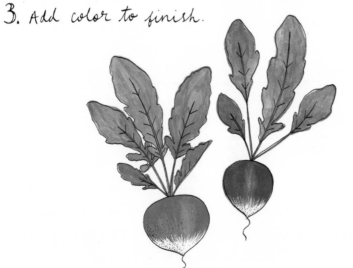

4. How about a
delicious summer salad?

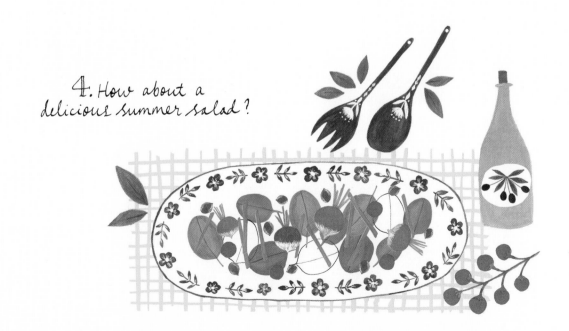

Drawing Plants

THERE ARE SO MANY THINGS TO SEE WHEN DRAWING PLANTS:

COLORS, SHAPES, TEXTURES, THE POT THEY STAND IN, AND SO ON.

WE ASKED NINE ILLUSTRATORS TO DRAW THEIR FAVORITE PLANT

AND TO SHARE ONE TIP ON HOW BEST TO DRAW YOUR OWN.

Ruby Taylor

Aphelandra squarrosa

"Look at the negative space between the leaves, too—that will help you get the shape of the leaves right. Also be exciting with color."

⬤◆ **Instagram**: @rubyst

⬤◆ ruby-taylor.co.uk

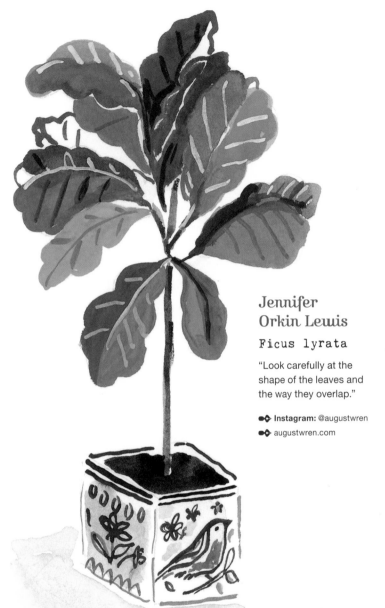

Jennifer Orkin Lewis

Ficus lyrata

"Look carefully at the shape of the leaves and the way they overlap."

⬤◆ **Instagram**: @augustwren

⬤◆ augustwren.com

Lotte Dirks

Maranta

"Use various layers on top of each other, preferably mixing materials. This gives your drawing some life. You could first use ink to apply an even layer of color, for example, and then add details in paint using a thin-tipped paintbrush."

⬤◆ **Instagram**: @lottedirks

⬤◆ greenhouseprints.com

Dinara Mirtalipova

Dieffenbachia

"First start by drawing the stems, then add wide leaves here and there. The beautiful pattern on the leaves can be painted using darker and lighter shades of green. And don't forget the pot, which you can decorate however you want."

Instagram: @mirdinara
mirdinara.com

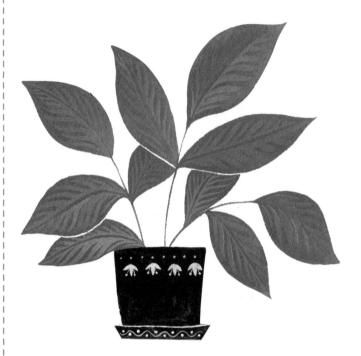

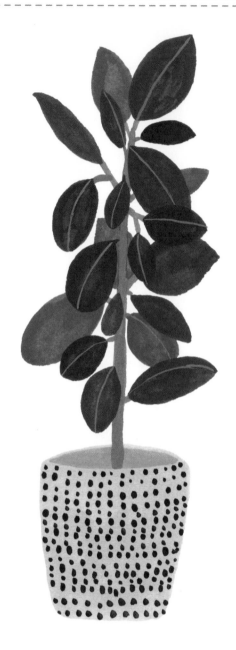

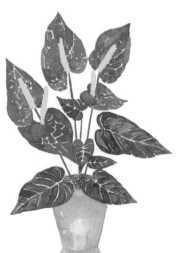

Sara Rocha

Anthurium

"Study the plant in detail first. Choose your color palette and then paint the plant in a layer-based way, adding the shades and highlights at the end."

Instagram: @sararrochaillustration
sararrocha.etsy.com

Kate Pugsley

Ficus elastica

"I like to paint plants without any planning beforehand. Painting several quick watercolor or gouache sketches on a page usually results in at least one or two that look fresh, interesting, and spontaneous."

Instagram: @katepugsley
katepugsley.com

Brie Harrison

Chlorophytum comosum

"Think of drawing a plant as being similar to a portrait. I don't think it's necessarily about capturing the preciseness of the leaf and stem; it's more about giving the plant a personality."

Instagram: @brieharrison

brieharrison.com

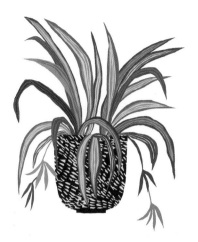

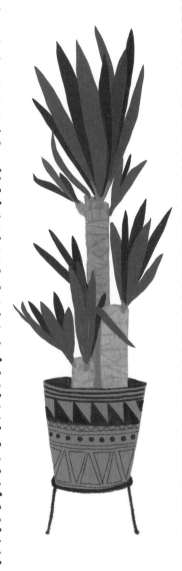

Elizabeth Barnett

Monstera

"Drawing from life helps you get different angles and perspectives on plants. Include the veins and roots to give it depth."

Instagram: @elizabethbarnett

elizabethbarnett.com

Anne Bentley

Yucca

"I pay special attention to the negative space when drawing plants and exaggerate it sometimes to make the composition more interesting."

Instagram: @annembentley

annembentley.com

how to draw GARDEN TOOLS
by DEBORAH VAN DER SCHAAF

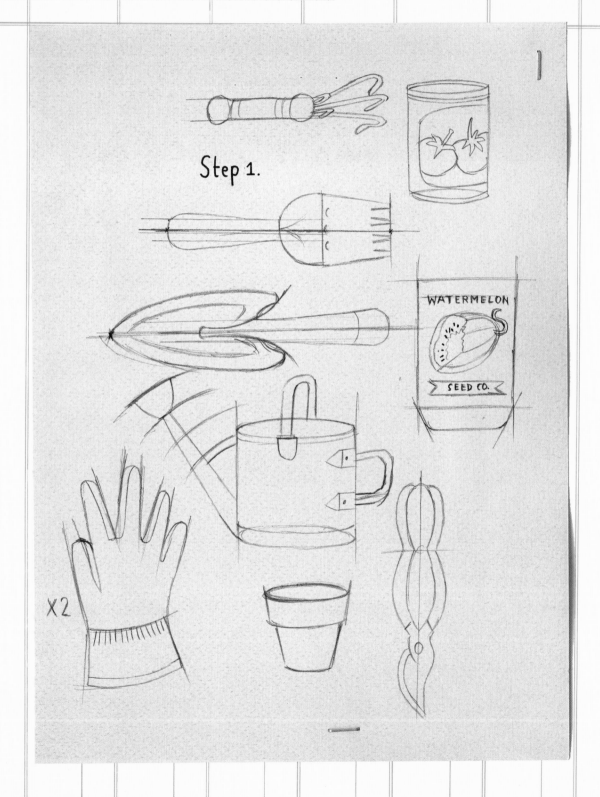

Step 1.

WATERMELON

SEED CO.

X2

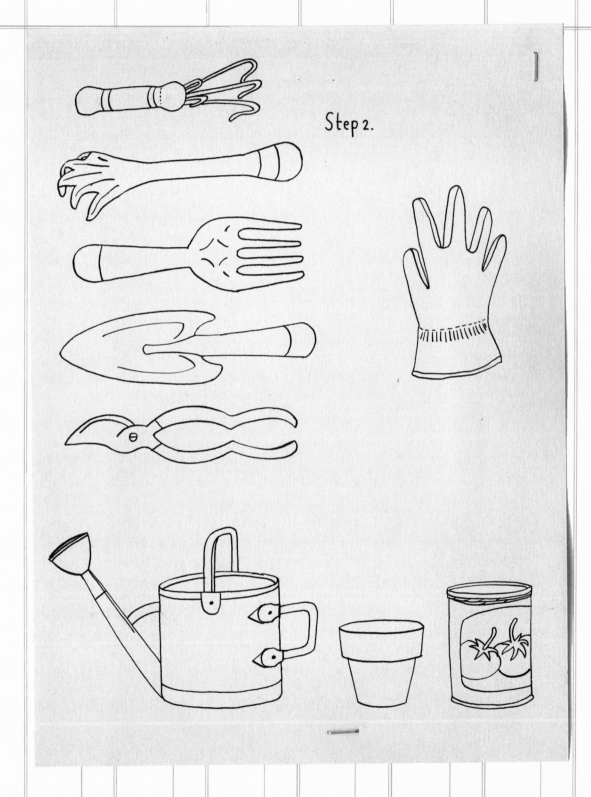

Step 2.

Part 3
STYLE

page 143

page 129

page 191

page 136

page 168

page 132

how to draw **A PARISIAN LADY**
by CELINDA VERSLUIS

1. Pick a portrait that you like
 and use it as inspiration.
 The end result will be
 your interpretation of this
 portrait and doesn't have
 to be an exact likeness.

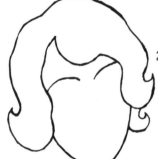

2. Begin with the hair. Then draw a simple
 face outline and some eyebrows.

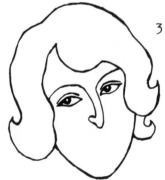

3. Connect the eyebrows with a
 line indicating a long elegant
 nose. Then draw the eyes;
 leave a little white dot in the
 center of each one.

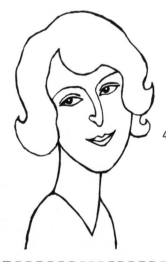

4. Draw the mouth, lips closed. Let the corners of the
 mouth point upward slightly for a friendly expression.
 Draw the neck and a neckline. Leave the hair as an
 outline or make it all black.

how to draw **A CAT**
by AMY VAN LUIJK

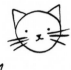

1.

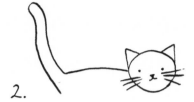

2.

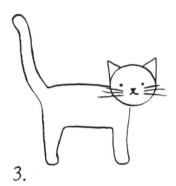

3.

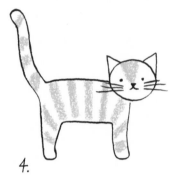

4.

 1.

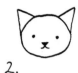 2.

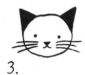 3.

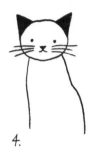 4.

5.

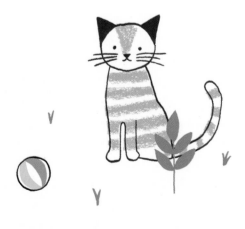

If you have a dog, alter the instructions to draw your pup instead. Simply leave out the whiskers, and change the shape of the ears and tail (and elongate the face if necessary) to reflect those of your pet.

how to draw HATS
by PETRA BAAN

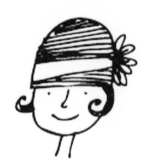

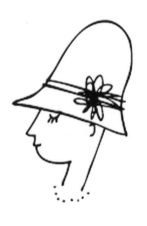

how to draw A COLLAR
by KATRIN COETZER

1. Begin by drawing the neckline.

2. Choose a collar style.

BURLINGTON

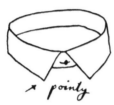

↗ *pointy*

MANDARIN

PETER PAN

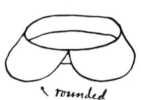

↖ *rounded*

SCALLOPED

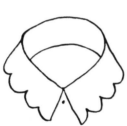

CHELSEA

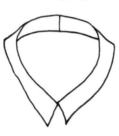

DOILY

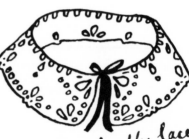

You can add details like embroidery or a little bow.

Create the lace effect by drawing lots of tiny holes.

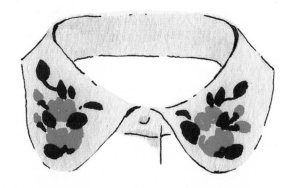

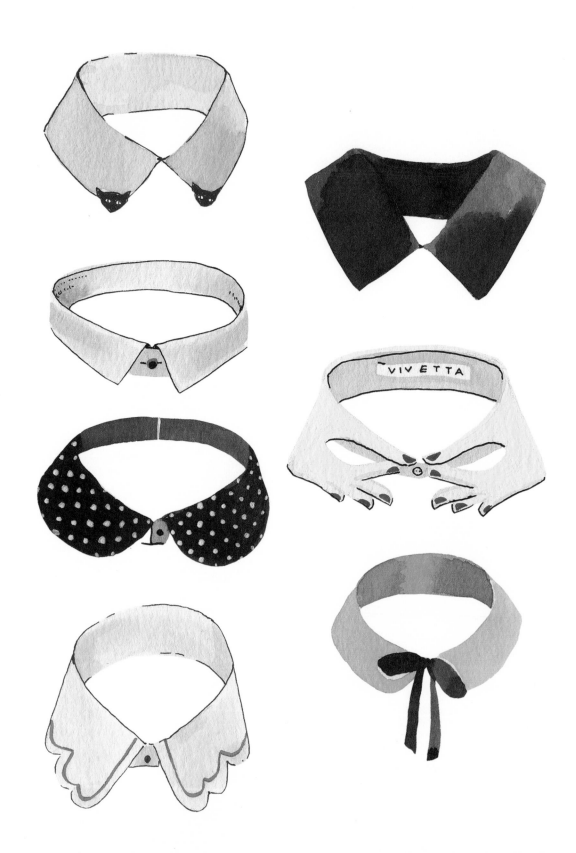

If you're feeling inspired, try drawing
a selfie (page 174), and then add
a collar and shirt or dress.

Dress Me Up

illustrated by Karen Weening

A SENSIBLE SKIRT OR BRIGHTLY PATTERNED PARTY PANTS?

A SWEATER OR A PRETTY SHIRT? USE COLORED PENCILS TO

DESIGN YOUR OWN STYLES USING THIS LITTLE BOOKLET.

how to draw **SWEDISH MITTENS**
by **FLORA WAYCOTT**

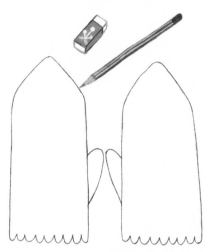

1. Draw the outline of the mittens.

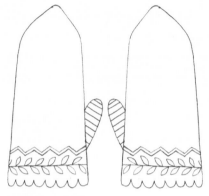

2. Draw the pattern on the cuffs and thumbs.

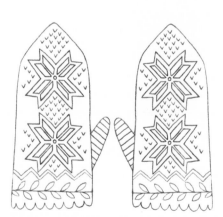

3. Fill in the rest of the pattern.

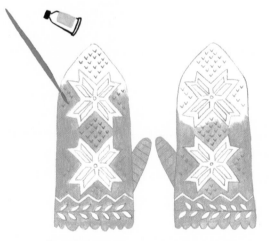

4. Fill in the background color.

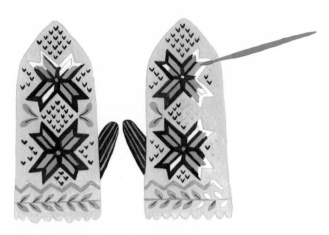

5. Color in the pattern.

What other patterns can you draw?

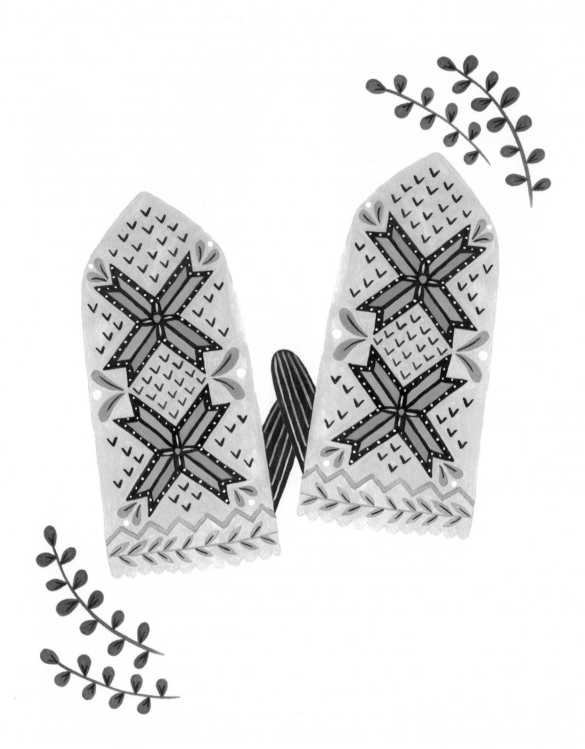

Marloes de Vries

MARLOES DE VRIES worked as a graphic designer and art director before switching her focus to illustration in 2010. She still creates design product packaging, book and magazine covers, and other features, but today she is most known for her hand-lettering, comics celebrating everyday life, and children's books. Marloes has always had an urge to create, finding little projects to work on like making robots out of shoe boxes and toilet paper rolls as a kid. A self-described daydreamer, Marloes loves to ride bicycles, eat pancakes, go hiking, collect picture books, travel, and bake cookies—all of these experiences inspire and inform her work.

LOCATION: **Rotterdam, Netherlands**

INSTAGRAM: **@marloesdevee**

WEBSITE: **marloesdevries.com**

this wonky thing
is a brush holder

watercolor
set bought
in 2010!

LUKAS

milky
tea ♡

TRAVEL
journal

Favorite Fineliner

obsessed with
← old PHOTOS

how to draw LETTERS
by VIKTOR CHALKBOARD & MARLIS ZIMMERMANN

1. Letters are forms.

2. ALWAYS: THIN STROKE UP, **THICK** STROKE DOWN.

3. You don't write letters...
YOU DRAW THEM.

Letter forms in fun fonts and styles
are a nice way to decorate gift
tags, snail mail, or your journal.

Try these hand exercises to
loosen your wrist.

Join two pens together with tape and hold them at a 30-degree angle to get dimension.

Sketch a letter in pencil, then fill in the space around it with a pattern or illustration.

Experiment with different size lobes, loops, tails, and arches.

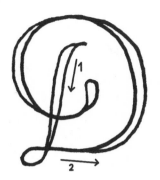

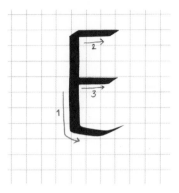

Try using a flat brush (8 mm) and ink. Let your hand move freely on the paper.

Add shadow to a bold letter to make it stand out even more.

Not all letters are included here. Many lessons about one letter can be applied to another. A lowercase *i* is like a *j* without the tail. A capital *L* has similar lines to a *K* or an *E*.

Try making a letter without a pen or pencil. How about paper, a ribbon, or string?

A letter like this K is made up of blocks, uniform in thickness, except where they connect. Try making an L and an M this way.

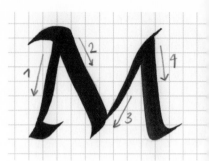

Draw different shapes and patterns within the outline of the letter.

Use a ruler and pencil to create this 3-D effect. Add shading (darker to the right, lighter to the left) to achieve even more depth.

Put as many curls and loops as possible in a single line.

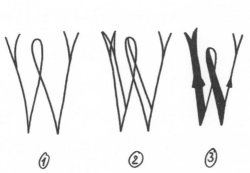

① ② ③

Place another *V* beside a *V* and you get a *W*.

Try making the bottom the exact reverse of the top.

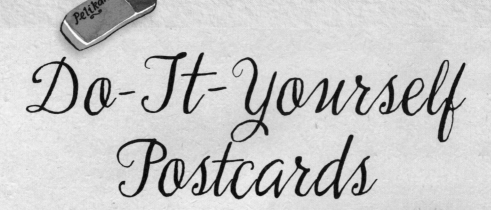

Do-It-Yourself Postcards

CRETACOLOR NERO soft 2 461 02 Austria

THE JOY OF RECEIVING A CARD IN THE MAIL THAT SOMEONE NOT ONLY WROTE
TO YOU PERSONALLY, BUT ALSO DECORATED WITH THEIR DRAWINGS:
WHAT COULD BE BETTER THAN THAT? BUT IT DOESN'T HAVE TO BE A DRAWING—
YOU COULD ALSO DECORATE IT WITH PRETTY BORDERS OR WITH A BEAUTIFUL
HAND-LETTERED QUOTE. YOU COULD EVEN STICK A NICE PICTURE
ON IT. OR LEAVE IT BLANK FOR THE RECIPIENT TO BE INSPIRED!

how to draw FLOURISHES & ACCENTS
by DEBORAH VAN DER SCHAAF

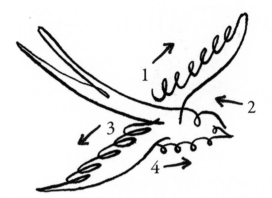

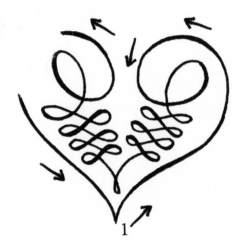

how to draw **GRANDMA'S TEACUP**

by ANNEMOON VAN STEEN

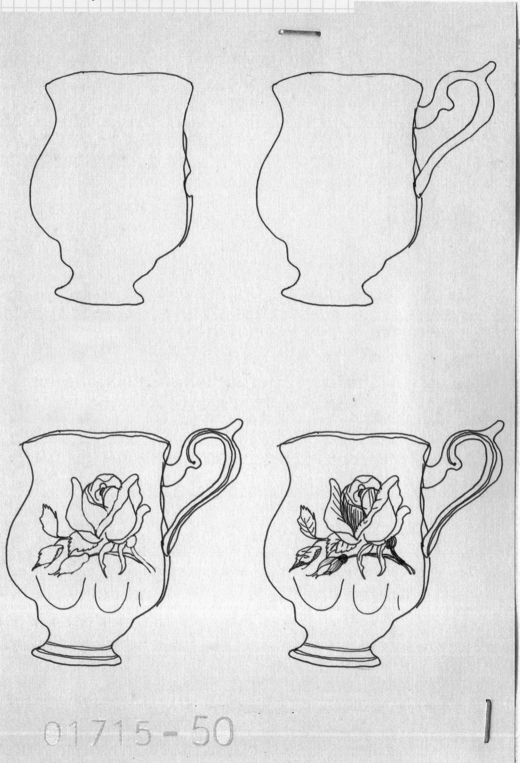

01715 - 50

01715 - 50

Sketching Style

interview by Jocelyn de Kwant
illustrated by Koosje Koene

DRAWING IS SOMETHING ILLUSTRATOR KOOSJE KOENE DOES EVERY DAY.

HER TIP? KEEP IT SIMPLE AND START WITH THE BASICS,

LIKE A SKETCHBOOK AND A PEN. BEFORE YOU KNOW IT,

YOU'LL BE DRAWING ALL DAY LONG.

Use a pen.

"For on-location sketching, all you need is a sketchbook and a pen. No pencil, because then you'll spend too much time erasing your work. If a line isn't perfect, just keep going: It doesn't have to be perfect. Relax your hand and don't press too hard on the paper. (And switch off that critical inner voice.)"

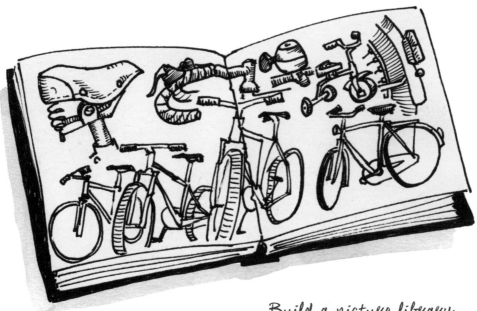

Build a picture library.

"I rarely refine my sketches; the sketch itself is the end result. It's a nice way to remember things, as well as good practice for drawing. The more you draw on location, the bigger your mental picture library of all the things you have ever drawn becomes."

"Color" with hatching.

"You can use hatching to color things in. Take a pen and draw lots of fine lines parallel to each other."

Skip perspective.

"Don't worry about perspective lines. When drawing a building, first draw the line where the sky stops and the building starts. By following the skyline, you don't get distracted by details or the building's perspective. You can add windows later, but you don't have to draw every last detail."

Get framed.

"Not sure where to start? Sketch some small frames onto your paper and in each one, draw a detail: a bicycle, a rain pipe, a bit of a roof. This is great to do when you have very little time."

Tip 1

"If you find it slightly overwhelming to go outdoors and draw on your own, find a group to join on urbansketchers.org or meetup.com."

Tip 2

"You don't have to draw everything you see; just leave out any difficult details. It doesn't have to be an exact replica: A sketch is your own interpretation of what you are looking at."

Tip 3

"When you sketch on location, all your senses are heightened, and you are more aware in the present moment. And when your sketchbook is full, you have a book full of memories."

how to draw **A BIKE**
by CLAUDIA PEARSON

1. Take a household glass, turn it upside down, and trace around the outside. Find a slightly smaller glass to make the inside of the tire. Repeat.

X2

2. From the center of the circles, draw intersecting lines to create the spokes.

3. From the middle of the front wheel, draw two lines in the 11 o'clock position. Extend them up to create the handlebar.

4. Draw the crossbar from the front bar and create a triangle down to the pedal. Make another triangle joining the back wheel.

5. Add a basket to the front (and color everything in!) and take a trip to the farmers' market.

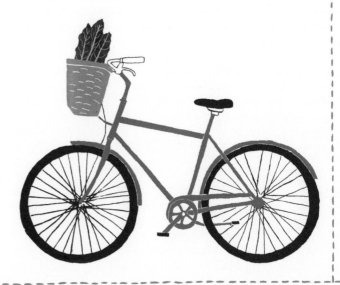

how to draw **A LUMBERJACK**
by DICK VINCENT

1. This man loves the great outdoors. To draw a beard, start with a color wash in the shape of a beard to keep him warm on his adventures, and add small hairlines to create texture. Finally, add a small mustache under the nose.

2. At night, he likes to build a fire to keep warm, so he carries an ax for firewood. This is how to draw an ax.

3.

His favorite item of clothing is a scruffy checked shirt. To draw one, use a color wash and add black ink in a check pattern, then add some darker squares at the intersecting lines to create the flannel look.

5.

He likes to smoke a pipe. Use either a gray wash or a pencil scribble to create the smoke.

4. Dogs are a man's best friend. This best friend is a Border Collie, who is both loyal and hardworking.

how to draw **A SELFIE**

by KATE PUGSLEY

1. Imagine your hair as a shape and draw it.

2. Fill in the space beneath the hair with your face and neck.

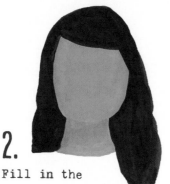

3. Give yourself a shirt. Fill in the shoulders around your hair and give the neckline a gentle scoop.

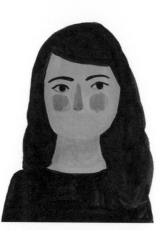

4. Fill in the shape of your eyebrows and eyes.

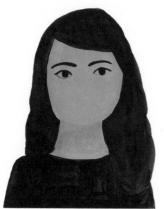

5. Add your nose and cheeks.

6. Add the shape of your lips in any expression you like.

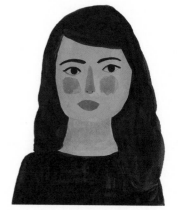

FROM THE ILLUSTRATOR: A teacher once pointed out to me, that in drawing, there are "lines people" and there are "shapes people." It clicked for me that I am definitely a "shapes person," and my drawing improved when I focused on large areas of color rather than perfect outlines.

Draw your selfie here.

Marloes de Vries

"Draw every day. A flowerpot on your windowsill, the dream you had last night . . . By practicing, you are developing the muscles in your hand and you will draw more easily, but you are also training your brain. You will see that, after drawing every day for forty days, your drawing will show significant improvement."

- **Instagram:** @marloesdevee
- marloesdevries.com

Jennifer Orkin Lewis

"If you only have ten minutes available, put on the timer daily and use that time to create. In a year, ten minutes a day is sixty hours of work! Use inexpensive paper and a favorite medium, and have a great time."

- **Instagram:** @augustwren
- augustwren.com

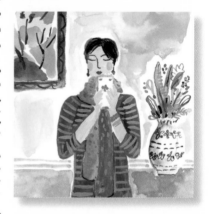

Yinfan Huang

"Loosen your grip on your pencil and relax your wrist when you draw—that frees your drawing as well as your mind. And don't be afraid to make mistakes—they're part of the fun!"

- **Instagram:** @yinfanhuang
- yinfanhuang.com

Maartje van den Noort

"Don't try too hard to draw neatly. Sometimes I catch myself 'copying' something, and I have to remind myself it's an interpretation, not a scientific drawing."

- **Instagram:** @maartjevandennoort
- maartjevandennoort.nl

Floor Rieder

"We were very frugal in my house when I was growing up. But never with drawing materials. My mother would allow me to pick out the highest-quality pencils—even when I was four years old. My tip: Don't skimp on materials. Pick different things and try them out. The sheets of paper with all your little test doodles are often little artworks in their own right."

Instagram: @floorrieder
floorrieder.nl

Amy Blackwell

"Do a little drawing or doodle even when you're not feeling inspired or motivated to create. Whether it's a simple pattern, a shape, or just a scribble—it doesn't have to be a work of art and you don't have to like it, but you'll be surprised at what jumps out at you from a fresh perspective later on."

Instagram: @amyjpeg
amyblackwell.co.uk

Danielle Kroll

"Sometimes I can feel intimidated by a blank sheet of paper. It's difficult to settle on just one thing to put on the page. To get through this creative block, I like to fill the page with several small compositions. It can be a series of simple doodles, pattern swatches, or tiny paintings."

Instagram: @daniellekroll
hellodaniellekroll.com

Irena Sophia

"My advice is a quote from one of my favorite book series, *A Series of Unfortunate Events* by Lemony Snicket."

"Are you ready?" Klaus asked finally.
"No," Sunny answered.
"Me neither," Violet said, "but if we wait until we're ready, we'll be waiting for the rest of our lives. Let's go."

➥ **Instagram:** @irena.sophia
➥ irenasophia.blogspot.com

Sarah Walsh

"Drawing, painting, creating . . . it's like a muscle. You have to work on it every day or at least every few days if you want to develop your own style. Try different pencils, pens, or paints until you find something that's in sync with your drawing style!"

➥ **Instagram:** @sarahwalshmakesthings
➥ sarahwalshmakesthings.com

Kim Welling

"Pick a subject to draw—plastic farm animals, for example. Follow the contour of the animal with your eyes, and as you do so, draw the line on the paper without looking down. What's more, don't take your pencil off the paper, either. Draw in one long line until you are back where you started. When you have done this a few times, you can also start including details in the silhouette. This way, you develop a stronger ability to translate what your eye sees into a drawing on paper. You also develop a better sense of shapes."

➥ **Instagram:** @kimslittlemonsters
➥ kimwelling.com

how to draw **DECORATIVE BORDERS**
by BODIL JANE

1.

2.

3.

4.

5.

6.

You can find patterns almost anywhere around you.

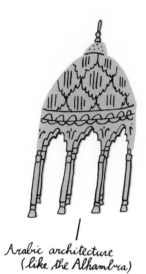

Arabic architecture (like the Alhambra)

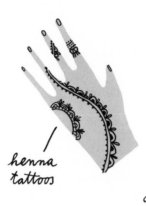

henna tattoos

a vintage lace dress

an old French decoration book

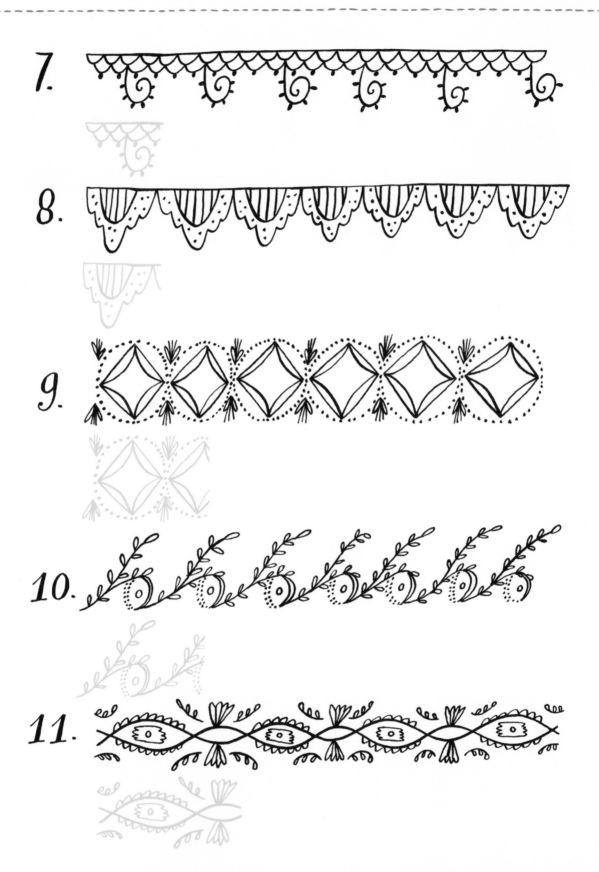

7.

8.

9.

10.

11.

India ink

dip pen

My Favorite Art Materials

interviews by Jocelyn de Kwant

EIGHT ILLUSTRATORS TELL US WHAT THEIR FAVORITE

ART MATERIAL IS AND WHY. PERHAPS YOU'LL BE INSPIRED

TO TRY SOMETHING NEW!

Rebecca Green

Gouache

"If acrylic and watercolor had a baby, it would be gouache. I mainly work with Designers Gouache by Winsor & Newton, and layer it with Prismacolor colored pencils. Recently, I've been experimenting with Holbein's Acryla Gouache; it doesn't mix so well with other materials, so it's easier to layer."

●➔ **Instagram:** @rebeccagreenillustration
●➔ myblankpaper.com

Ruby Taylor

Cretacolor black pencil

"I love the texture it makes on the page; it's blacker than a usual pencil. It has the color of charcoal but it's softer and less brittle. I haven't ever found anything quite as good!"

●➔ **Instagram:** @rubyst
●➔ ruby-taylor.co.uk

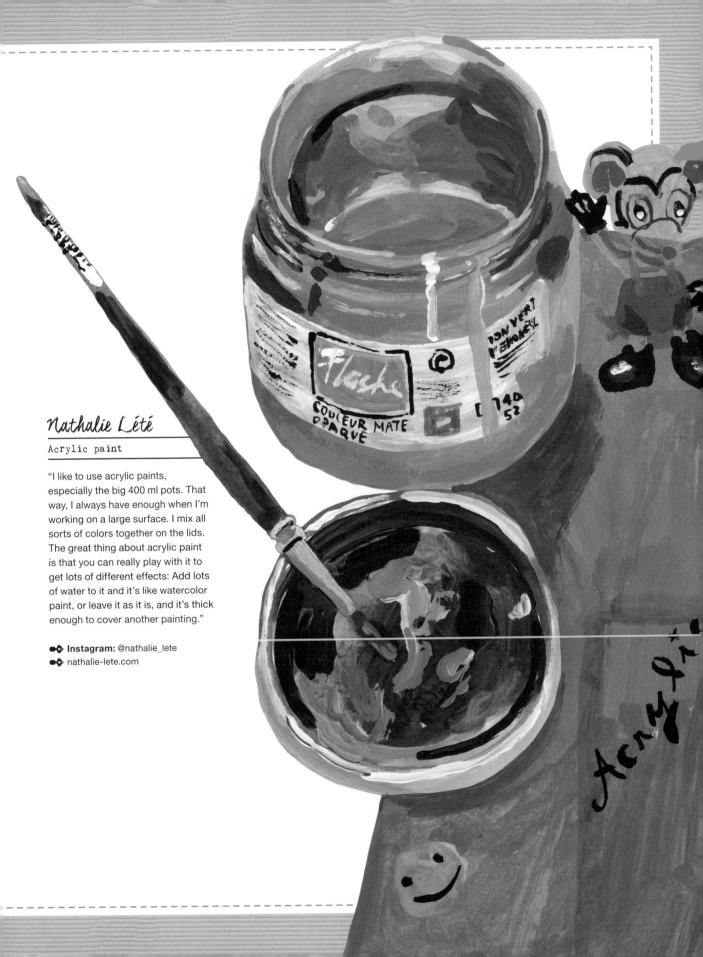

Nathalie Lété

Acrylic paint

"I like to use acrylic paints, especially the big 400 ml pots. That way, I always have enough when I'm working on a large surface. I mix all sorts of colors together on the lids. The great thing about acrylic paint is that you can really play with it to get lots of different effects: Add lots of water to it and it's like watercolor paint, or leave it as it is, and it's thick enough to cover another painting."

◖◗ **Instagram:** @nathalie_lete
◖◗ nathalie-lete.com

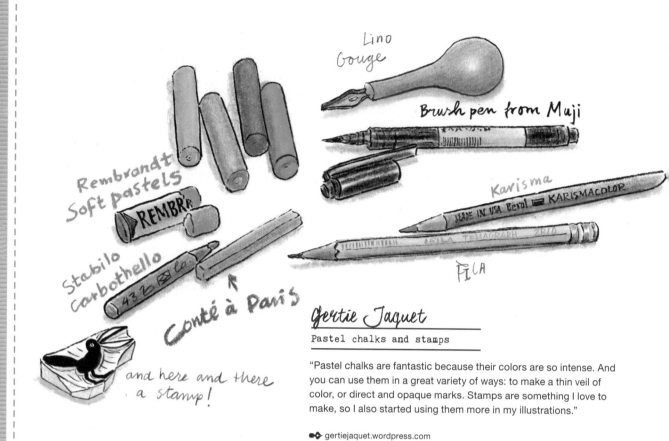

Lino Gouge

Brush pen from Muji

Rembrandt Soft pastels

REMBRA

Karisma

MADE IN USA Berol KARISMACOLOR

FILA TEMAGRAPH 2B

FILA

Stabilo Carbothello

43.2

Conté à Paris

and here and there a stamp!

Gertie Jaquet

Pastel chalks and stamps

"Pastel chalks are fantastic because their colors are so intense. And you can use them in a great variety of ways: to make a thin veil of color, or direct and opaque marks. Stamps are something I love to make, so I also started using them more in my illustrations."

●◆ gertiejaquet.wordpress.com

Angela Keoghan

Printing roller and ink

"I love to use my printing roller and ink when I want to create textures for my illustrations. I particularly like how, with each handprint, something unexpected emerges—like a different density of mark, depending on how dry the ink or how absorbent the paper is."

●◆ **Instagram:** @angelakeoghan
●◆ thepicturegarden.co.nz

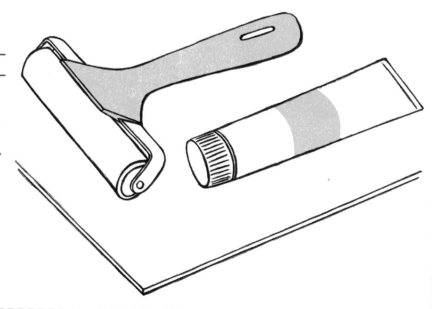

Anja Mulder
Fineliner

"I make all my drawings with the same type of fineliner—a Rollerball pen from [the Dutch store] HEMA. The lines are dark enough, and I can make thin scratchy ones or heavy ones. To sketch, I use a 'normal' HB pencil. Not too hard, not too soft."

●◆ **Instagram:** @deblauwebeer
●◆ anjamulder.com

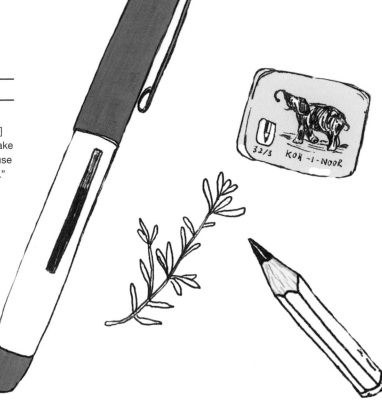

Geertje Aalders
Pen knife

"My pen knife is very special to me: My grandmother gave it to me when I was just seven. Far too young to have such a sharp blade, but I knew how to use it properly. As I grew from a kid who was continually crafting into a professional illustrator, my grandmother always proudly watched from the sidelines."

●◆ **Instagram:** @geertjeaalders
●◆ geertjeaalders.nl

Lieke van der Vorst
Ballpoint and colored pencils

"When you draw with ballpoint and colored pencils, every line counts—which can also work against you sometimes. I use Caran d'Ache pencils, the ones with the golden edge; they are a bit waxy. Softer pencils would smudge too much because I am left-handed."

●◆ **Instagram:** @Liekevandervorst
●◆ liekeland.nl

how to draw **SWIM CAPS**
by YELENA BRYKSENKOVA

STEP 1.

STEP 2.

STEP 3.

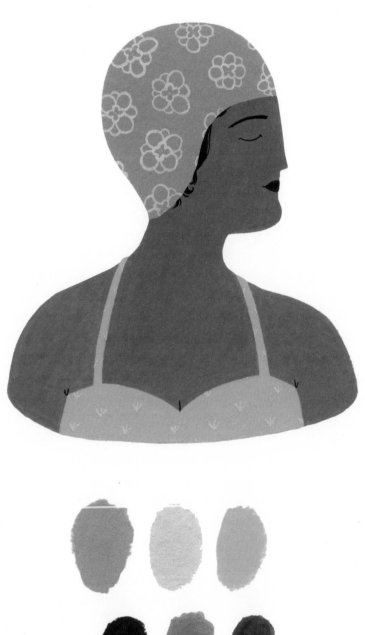

Part 4

NATURE

*

Drawing lessons
about nature

*

The joy of camping

*

A watercolor
lesson and
watercolor paper

*

Color techniques

*

how to draw **LEAVES**
by FLORA WAYCOTT

LEAF STUDIES

1. Pointy

2. Spiky

3. Round

4. Small

PLANT STUDIES

How many varieties can you find?

STARGAZING

CAMPFIRE

HOT COFFEE

COZY TENT

GATHERING FIREWOOD

NATURE-WATCHING

FORAGING

CANOEING

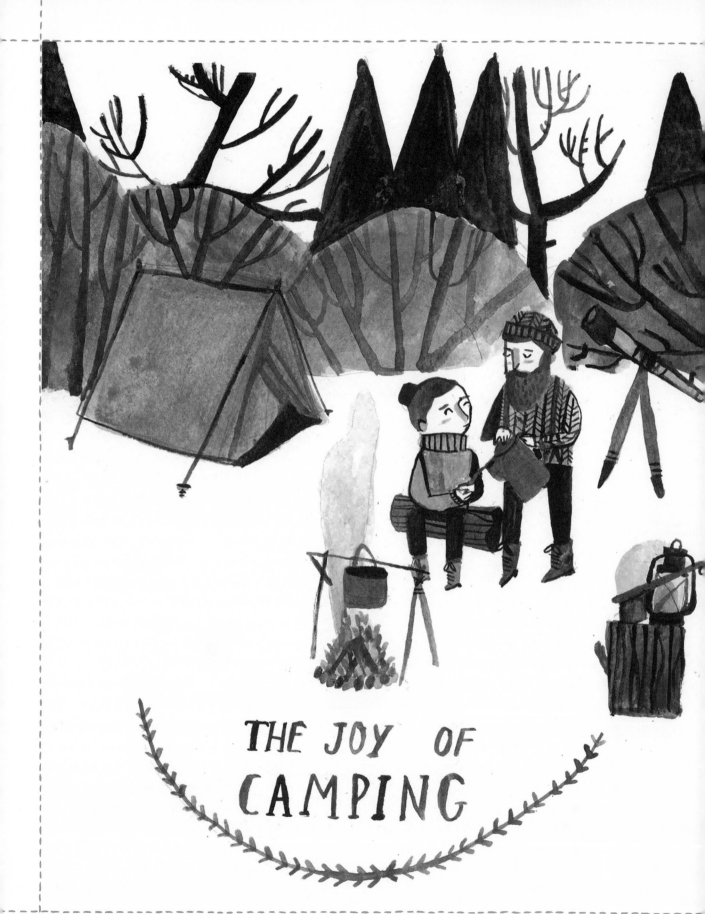

THE JOY OF CAMPING

how to draw **A CAMPER**
by **KATRIN COETZER**

1. Draw the basic shape of your camper.

2. Fill in essential elements like windows, wheels, and a tow hook.

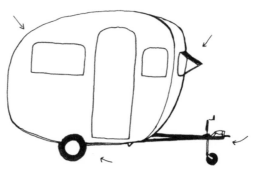

3. Next you can add an awning for shade, a gas canister for cooking, a picnic table, and some chairs.

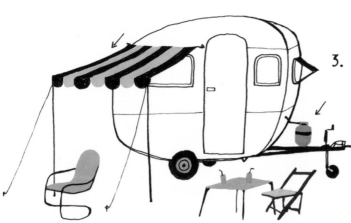

4. Color your camper in two different hues.

5. Just for fun, draw a plant or two.

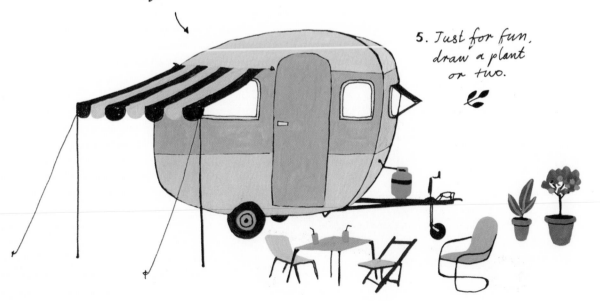

There are many different styles of
campers and trailers. Try searching
#camping online to find your dream
camper. Then draw it!

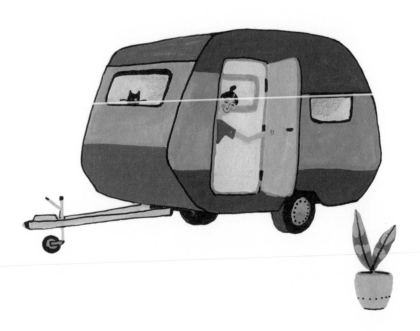

Louise Lockhart

LOUISE LOCKHART is a freelance illustrator who lives in an old mill in a small town in England, where she spends most of her days in her studio creating designs from paper cutouts and line drawings. Her process is varied: She creates her paper cutouts and drawings, then compiles them in Photoshop before adding in color and texture. In 2012, she founded The Printed Peanut, a one-woman design firm specializing in toys, games, clothes, and accessories. Louise finds inspiration in normal everyday life such as food packaging, tickets, posters, and men who wear suits and hats. She feels lucky to be able to make art for a living; she also loves being her own boss and advises other aspiring illustrators out there to stay true to their own path.

LOCATION: **Yorkshire, England**

INSTAGRAM: **@theprintedpeanut**

WEBSITE: **theprintedpeanut.co.uk**

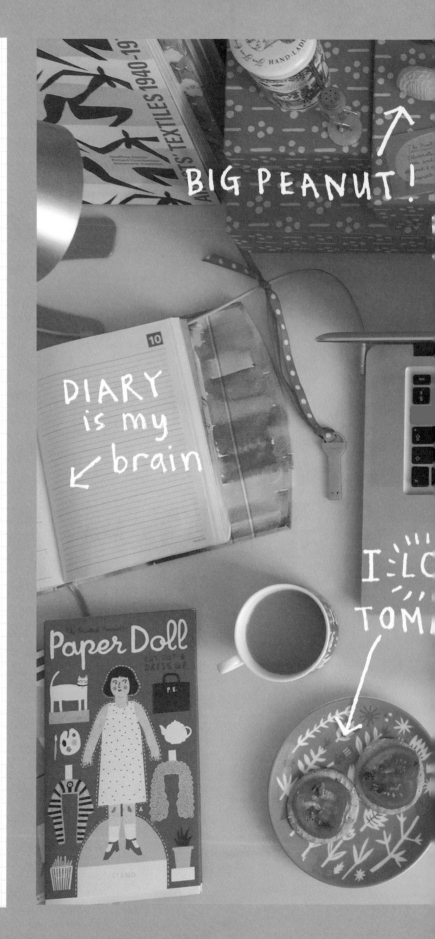

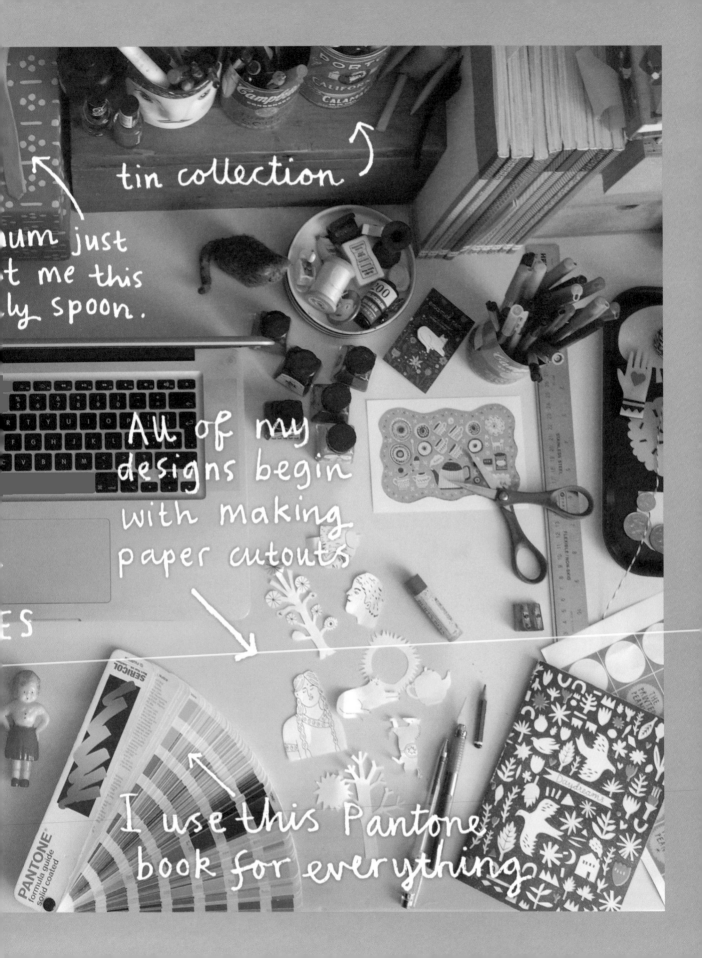

tin collection

um just
t me this
ly spoon.

All of my
designs begin
with making
paper cutouts

ES

I use this Pantone
book for everything

how to draw **A WOOD CABIN**
by **LIZZY STEWART**

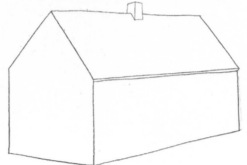

① Draw the outline of the house.

② Draw the windows and a door.

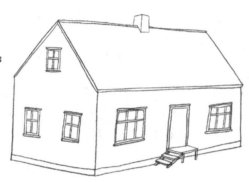

③ Make the walls of wood.

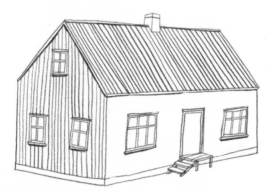

④ Draw some more lines.

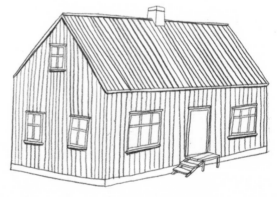

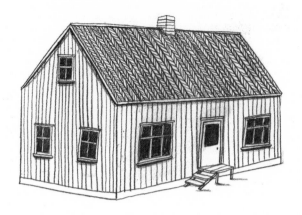

(5) Fill in the details.

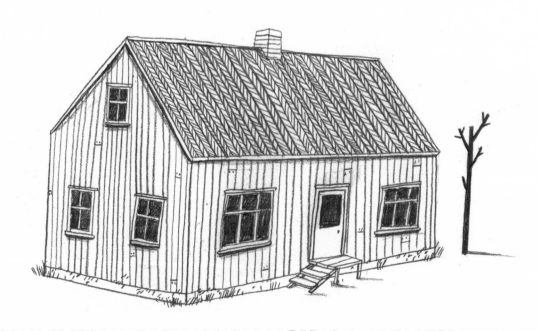

Once you're finished, feel free to
add some color to the house. Drawing
trees, a yard, and some landscaping
is a fun way to incorporate your
favorite season (or try all four).

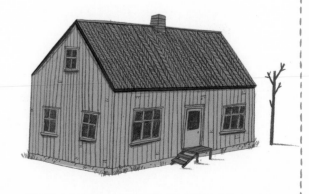

45

how to draw A THERMOS
by KATRIN COETZER

1. Begin by drawing a set of parallel lines to form the cylinder.

2. Complete the shape.

3. Add some detail and shading.

4. Decorate your thermos.

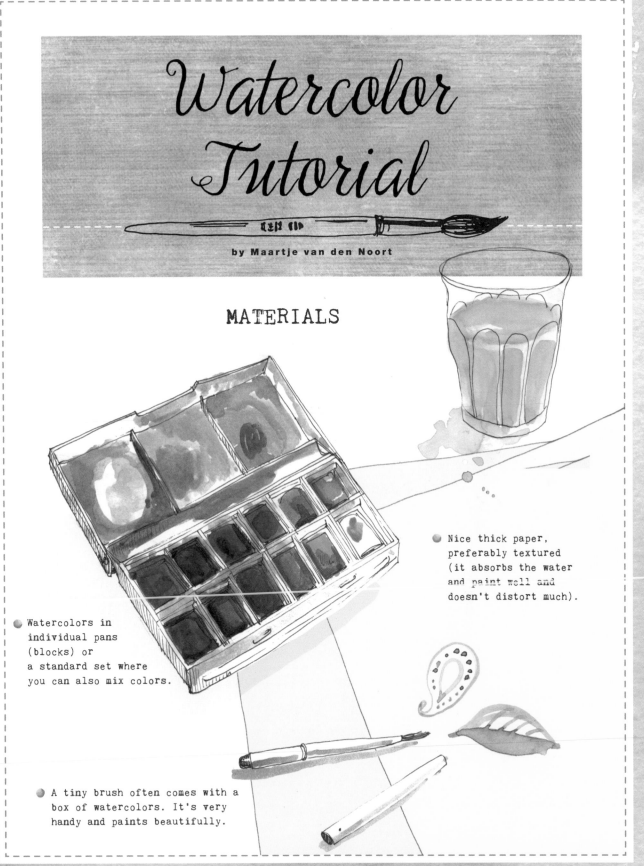

Watercolor Tutorial

by Maartje van den Noort

MATERIALS

● Nice thick paper,
preferably textured
(it absorbs the water
and paint well and
doesn't distort much).

● Watercolors in
individual pans
(blocks) or
a standard set where
you can also mix colors.

● A tiny brush often comes with a
box of watercolors. It's very
handy and paints beautifully.

EXPERIMENT

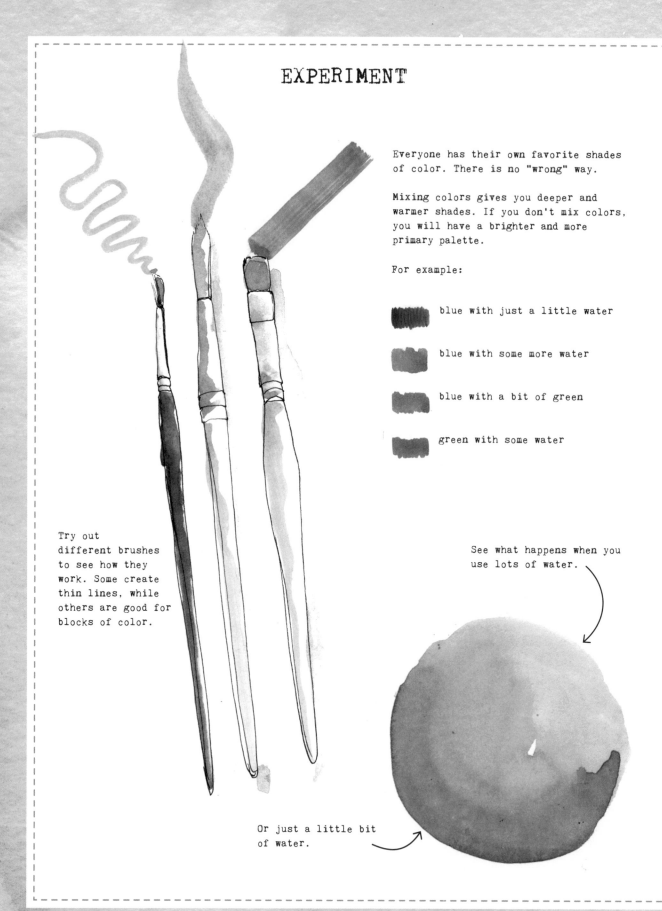

Everyone has their own favorite shades of color. There is no "wrong" way.

Mixing colors gives you deeper and warmer shades. If you don't mix colors, you will have a brighter and more primary palette.

For example:

blue with just a little water

blue with some more water

blue with a bit of green

green with some water

Try out different brushes to see how they work. Some create thin lines, while others are good for blocks of color.

See what happens when you use lots of water.

Or just a little bit of water.

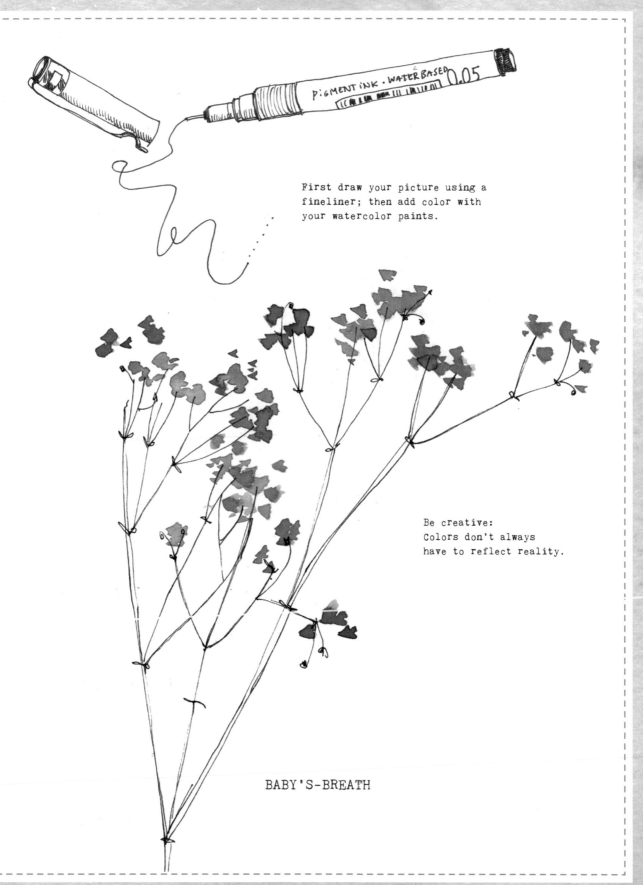

First draw your picture using a
fineliner; then add color with
your watercolor paints.

PiGMENT iNK · WATER BASED 0.05

Be creative:
Colors don't always
have to reflect reality.

BABY'S-BREATH

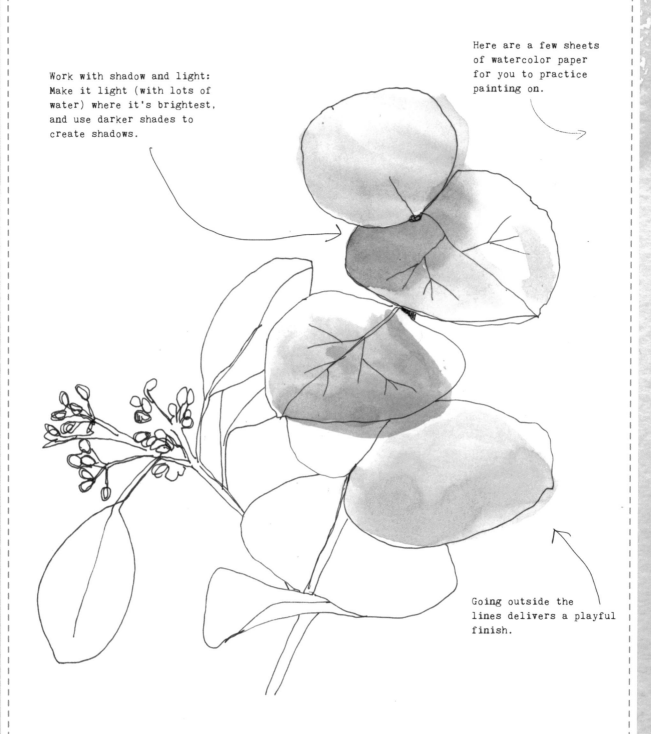

Work with shadow and light:
Make it light (with lots of
water) where it's brightest,
and use darker shades to
create shadows.

Here are a few sheets
of watercolor paper
for you to practice
painting on.

Going outside the
lines delivers a playful
finish.

EUCALYPTUS

how to draw **FLOWERS**
by LILA RUBY KING

Step
❶

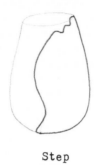

Step
❷

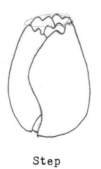

Step
❸

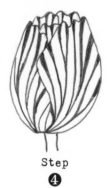

Step
❹

Step
❶

Step
❷

Step
❸

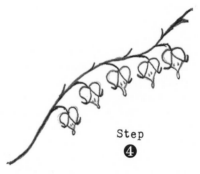

Step
❹

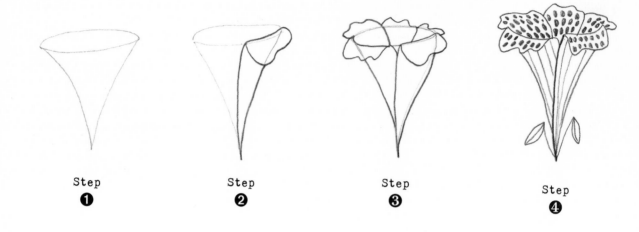

Step **❶**

Step **❷**

Step **❸**

Step **❹**

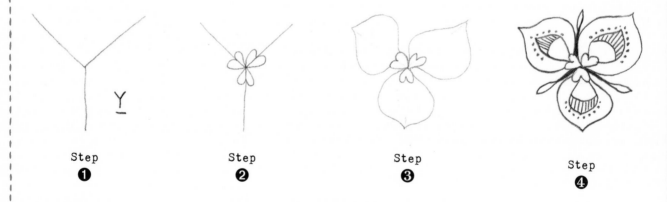

Step **❶**

Step **❷**

Step **❸**

Step **❹**

Add your own flowers to this
cluster of illustrated blooms.

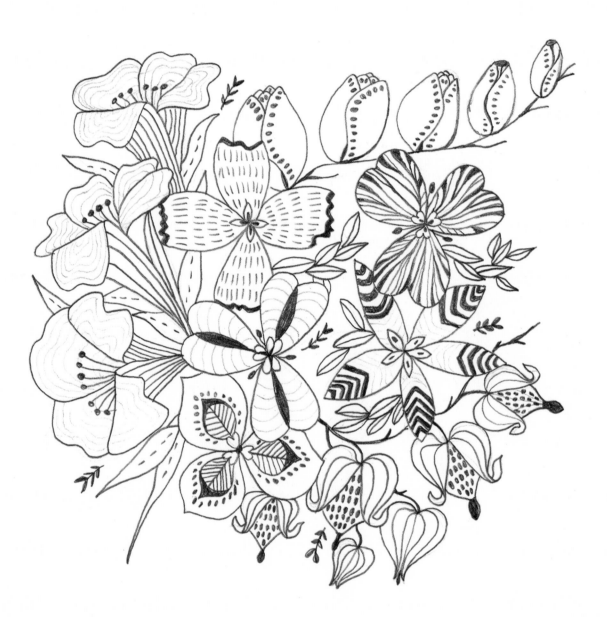

47

how to draw A SEAGULL

by ANNEMOON VAN STEEN

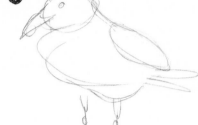

YOU NEED:
- Pencil
- Eraser
- Fineliner
- Brush
- Watercolor paint

Lightly draw the silhouette.

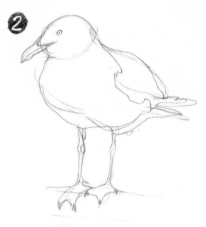

Now draw your lines with more definition.

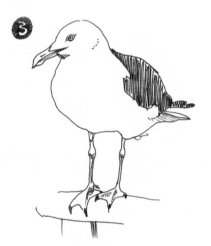

"Trace" the outline with a pen, then add details (erase any remaining pencil lines).

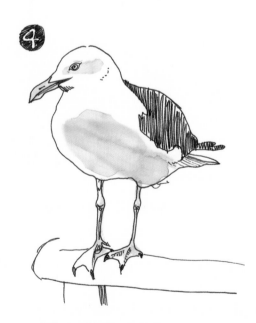

Add a simple layer of color (a wash); let it dry.

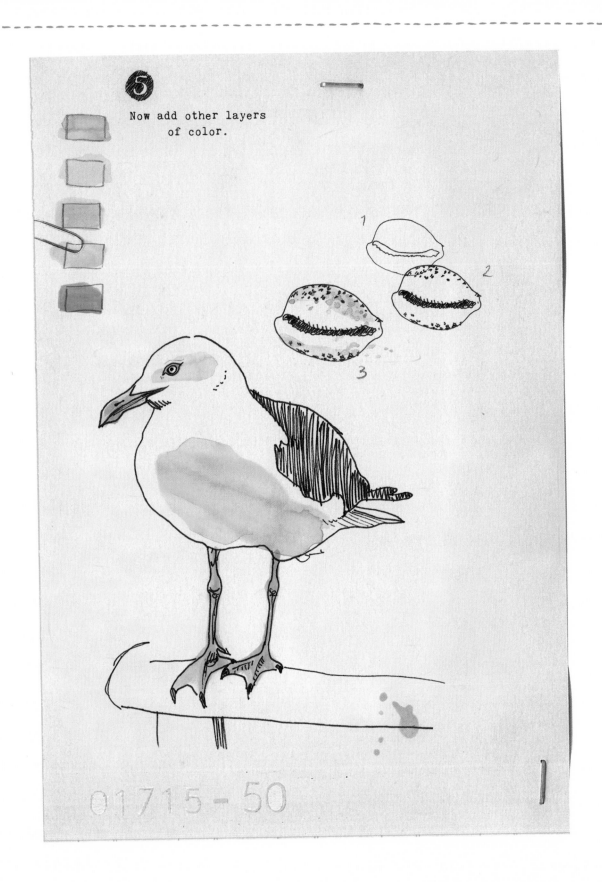

5 Now add other layers of color.

how to draw **TENTS**
by SANNY VAN LOON

①

②

③

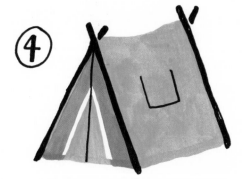

④

Try using color to draw shapes
rather than lines.

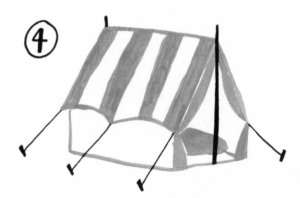

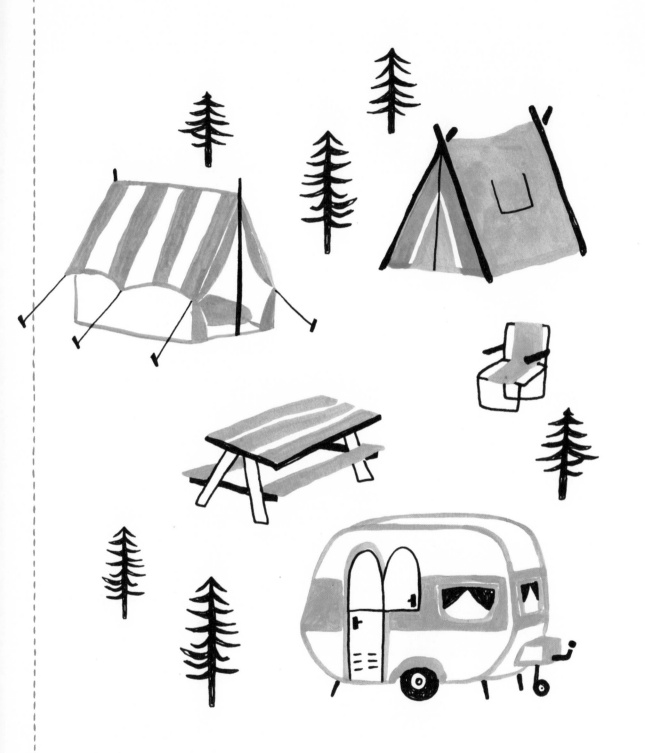

About Color

by Deborah van der Schaaf

COLOR, HOWEVER IT'S APPLIED (WHETHER WITH PAINT, MARKERS,

PENCILS, OR CRAYONS), IS A WAY TO ADD ENERGY, REALISM,

OR ABSTRACTION TO A SKETCH OR DRAWING. IN THE NEXT FEW PAGES,

LEARN ABOUT AND EXPERIMENT WITH DIFFERENT TECHNIQUES

OF ADDING COLOR TO YOUR WORK.

MATERIALS

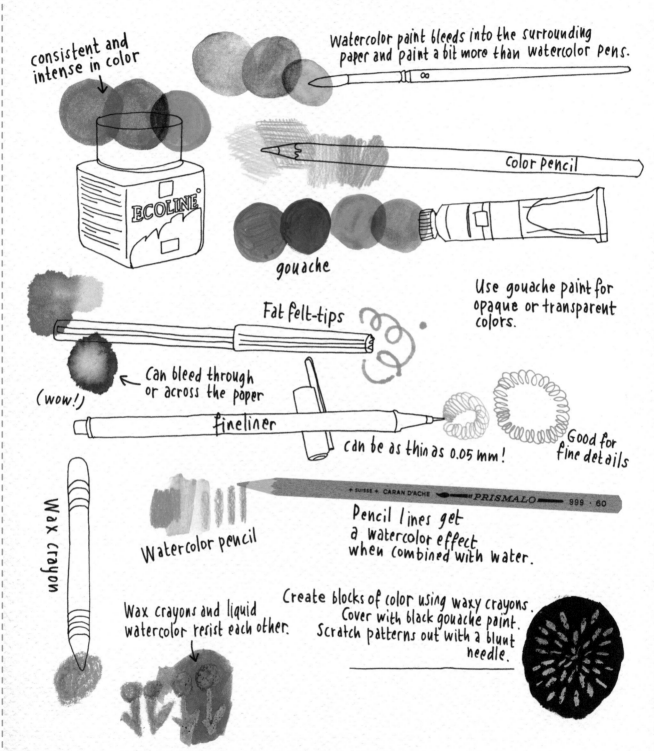

consistent and intense in color

Watercolor paint bleeds into the surrounding paper and paint a bit more than watercolor pens.

ECOLINE

color pencil

gouache

Use gouache paint for opaque or transparent colors.

Fat felt-tips

Can bleed through or across the paper

(wow!)

fineliner

can be as thin as 0.05 mm!

Good for fine details

Wax crayon

Watercolor pencil

+ SUISSE + CARAN D'ACHE ◆ᴇ PRISMALO 999 · 60

Pencil lines get a watercolor effect when combined with water.

Wax crayons and liquid watercolor resist each other.

Create blocks of color using waxy crayons. Cover with black gouache paint. Scratch patterns out with a blunt needle.

Test materials here—experiment by mixing, layering, scratching, and smudging the colors.

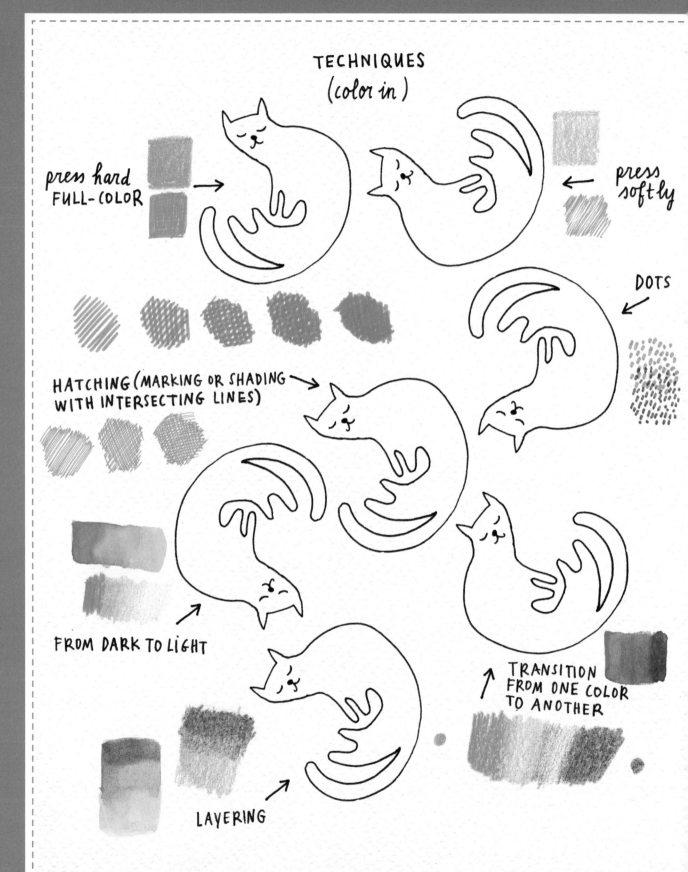

TECHNIQUES
(color in)

press hard
FULL-COLOR

press
softly

DOTS

HATCHING (MARKING OR SHADING
WITH INTERSECTING LINES)

FROM DARK TO LIGHT

TRANSITION
FROM ONE COLOR
TO ANOTHER

LAYERING

COLOR PALETTES

- **PRIMARY COLORS** →
Traditional: red, yellow, blue
(magenta, yellow, cyan in printer
inks) can be mixed to create other colors.

(color in and mix)

- **COMPLEMENTARY COLORS** are
opposites on the
color wheel.

- Use a color scheme
from a picture you love.

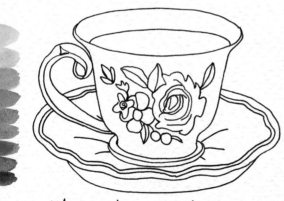

- Warm colors can cheer you up.

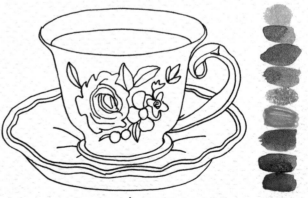

- Cool colors can calm you.

Color in the line drawing on the opposite page using the tips and techniques you learned on pages 230–233. Then make your own image here.

how to draw AN APPLE TREE
by AMY VAN LUIJK

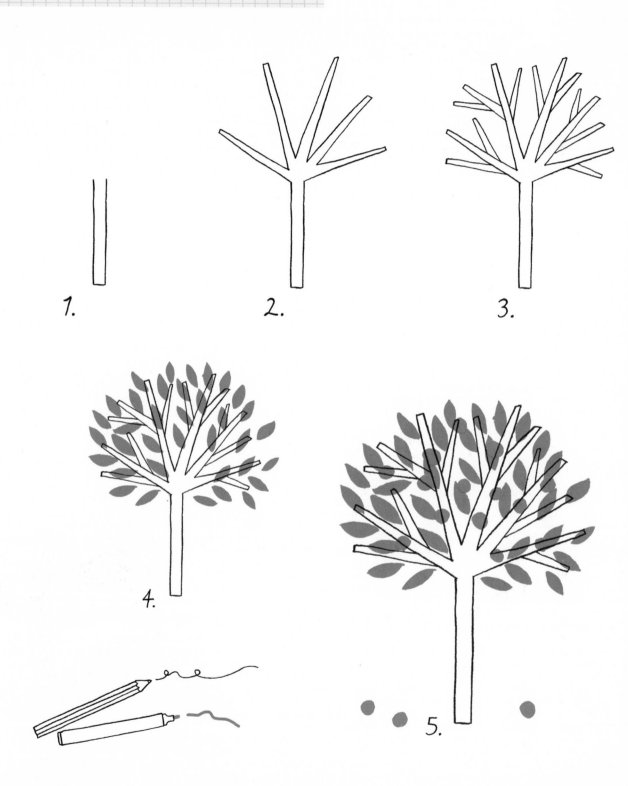

1.

2.

3.

4.

5.

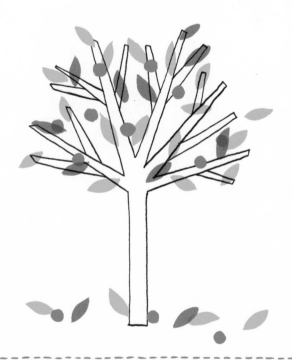

how to draw **A PLANT**
by FLORA WAYCOTT

❧1❧
Draw the stem of the plant.

❧2❧
Add leaves.

❧3❧
Draw a line through each leaf.

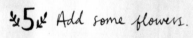

❧4❧
Draw more lines for detail.

❧5❧ Add some flowers.

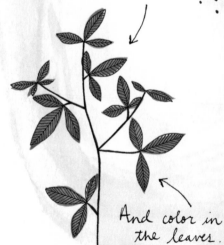

And color in the leaves. How lovely!

Sit back and admire your drawing!

Keep On Drawing

by Caroline Buijs
illustrated by Karen Weening

USE THE HALF-FINISHED DRAWINGS BY ILLUSTRATOR KAREN WEENING

AND THE DRAWING PROMPTS BY CAROLINE BUIJS TO CONTINUE

TO HONE YOUR SKILLS AND EXPLORE YOUR PRACTICE.

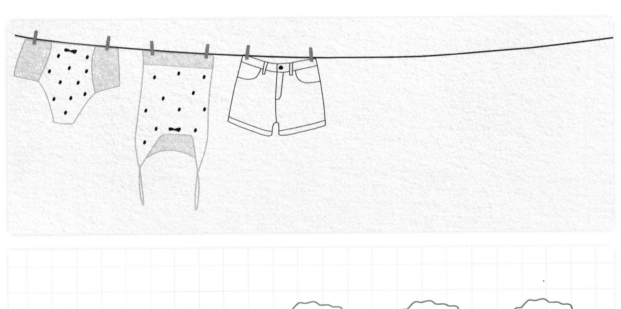

※ Give yourself three minutes to draw the contents of your pencil case.

※ Look down and draw your shoes—one minute per shoe.

※ Try to draw the cover of the book you're reading in two minutes.

✳ Find a spot in the park and draw the scene in front of you in five minutes.

✳ Draw your cat in one minute (before it moves away again).

Set the table for breakfast one Sunday morning—tablecloth and all—and draw it in three minutes.

OFFLINE
IS THE
NEW
LUXURY

✳ Draw a portrait of the person sitting across from you
in one minute (at work, in school, or on the train).

* Draw six objects from nature in six minutes (a shell, a twig, a piece of coral, a pinecone, etc.).

* Draw your favorite piece of clothing in three minutes.

Credits

TEXT

Caroline Buijs: pages 68–74, 176–178, 241–246; **Jocelyn de Kwant:** pages 146–147, 162–167, 186–189; **Maartje van den Noort:** pages 215–218; **Deborah van der Schaaf:** pages 229-235; **Karen Weening:** pages 40–42.

NOTE: Text quoted by Irena Sophia on page 178 is excerpted from the book *The Ersatz Elevator: A Series of Unfortunate Events #6* by Lemony Snicket (HarperCollins). Some of the insights and tips on page 69 are excerpted from the book *Art Before Breakfast* by Danny Gregory (Chronicle Books).

ILLUSTRATIONS

Geertje Aalders: page 189 (bottom left); **Petra Baan:** pages 132–133; **Elizabeth Barnett:** page 119 (bottom left); **Anne Bentley:** page 119 (top right); **Juliette Berkhout:** page 58 (bottom left); **Amy Blackwell:** pages ix (top), pages 100–101 (photo), 177 (bottom left), 179 (bottom right); **Yelena Bryksenkova:** pages 14–15, 190–192; **Viktor Chalkboard:** pages 148–153; **Katrin Coetzer:** pages ix (bottom right), 4–6, 34–35, 48–51, 54, 56–57, 59–61, 64–67, 134–136, 200–202, 205, 212–214; **Marloes de Vries:** pages 146–147 (photo), 176 (top left), 179 (bottom right), 248 (middle); **Lotte Dirks:** page 117 (bottom right); **Carolyn Gavin:** pages 30–31 (photo); **Getty Images:** background and borders, pages 116–119 Engin Korkmaz/iStock/Getty Images Plus; **Rebecca Green:** page 186 (middle); **Brie Harrison:** page 119 (top left); **Yinfan Huang:** pages 176 (bottom left), 179 (top right); **Emily Isabella:** pages 12, 82–83; **Bodil Jane:** pages v (border), 22–25, 32–33, 154 (top, bottom, border), 180–184; **Gertie Jaquet:** page 188 (top); **Angela Keoghan:** page 188 (bottom); **Lila Ruby King:** pages 102–104, 219–221; **Koosje Koene:** pages 162 (top), 163–167; **Danielle Kroll:** pages 177 (bottom right), 179 (top left); **Nathalie Lété:** page 187; **Louise Lockhart:** pages 206–207 (photo); **Dinara Mirtalipova:** page 118 (top left); **Anja Mulder:** page 189 (top); **Jennifer Orkin Lewis:** pages 105–106 (*Draw Every Day, Draw Every Way: Sketch, Paint, and Doodle Through One Creative Year* by Jennifer Orkin Lewis (Abrams Noterie, 2016)), 117 (top right), 176 (top right), 179 (top middle); **Claudia Pearson:** pages ii (center), iv (center), 168, 171; **Kate Pugsley:** pages 118 (top right), 174, 179 (middle bottom); **Floor Rieder:** pages 177 (top), 179 (bottom left); **Sara Rocha:** page 118 (bottom left); **Shutterstock.com:** background, pages i, 250; flowers and color wash, pages iv–v; circle designs, pages vi–1; frame, page 1; oval design, pages 30, 100, 146, 206; paintbrush, pages 40, 69, 73, 116, 162, 186, 215, 229, 240; background, page 58; ink pen, pages 69, 90; paper textures, pages 70–74, 154, 240–246, 248–249; frames, page 179; purple background, page 229; graphite pencil, pages 68, 71, 246; paint tube, page 69; paperclip, pages 70, 74; pencil, pages 58, 74; pencil sharpener, page 68; flower branches, page 247; **Irena Sophia:** pages 178 (top left), 179 (middle right); **Lizzy Stewart:** pages 208–210; **Sayaka Sugiura:** pages 90 (top), 91 from *Etegami Book* (KK Bestseller) with thanks to Coco Tashima, "Draw Inside the Box" booklet; **Ruby Taylor:** pages vii (bottom), 117 (middle left), 154 (middle), 186 (bottom); **Maartje van den Noort:** pages 176 (bottom right), 215–218; **Deborah van der Schaaf:** pages ii (bottom), iv (bottom), 8–10, 20–21, 110–113, 120, 122–124, 155–157, 229–230, 232–235; **Lieke van der Vorst:** page 189 (bottom right); **Sanny van Loon:** pages 26–29, 94–99, 224, 226–228; **Amy van Luijk:** pages 52–53, 128–130, 236–237; **Annemoon van Steen:** pages 36–38, 43–44, 46, 62, 84, 86, 88, 158–160, 222–223; **Celinda Versluis:** pages 126–127; **Dick Vincent:** pages 172, 196–198; **Sarah Walsh:** pages 178 (top right), 179 (top left); **Flora Waycott:** pages 16–19, 76, 79, 80–81, 92, 107–109, 114–115, 140–145, 194–195, 238; **Karen Weening:** pages 40–42, 138–139, 240–246, "A House to Draw In" foldouts, "Dress Me Up" booklet; **Kim Welling:** pages 178 (bottom right), 179 (middle left); **Monique Wijbrands:** page 58 (bottom right); **Marlis Zimmerman:** pages 148–153.

About the Authors

IRENE SMIT AND ASTRID VAN DER HULST are the creative directors of *Flow* magazine, a popular international publication packed with paper goodies and beautiful illustrations that celebrates creativity, imperfection, and life's little pleasures. Astrid and Irene began their magazine careers as editors at *Cosmopolitan* and *Marie Claire*. In 2008, inspired by their passion for paper and quest for mindfulness, Irene and Astrid dreamed up the idea for their own magazine in a small attic and haven't looked back since. They live with their families in Haarlem, Netherlands.